ARTS
& Artisans Trails

of Cape Cod, Martha's Vineyard & Nantucket

Second Edition

Project Manager
Clare O'Connor

Chief Author
Laura M. Reckford

Design
Margo Tabb
Margo Tabb Graphic Design, Inc.
P.O. Box 451, Marstons Mills, MA 02648

Published by
Cape Cod Chamber of Commerce
5 Shoot Flying Hill Road
Centerville, MA 02632
(508) 362-3225

For book orders call or go online
888-33-CAPECOD
www.CapeAndIslandsArtsGuide.com

©2009

This guidebook was developed under the auspices of the Cape Cod Chamber of Commerce, in partnership with Coastal Community Capital, Nantucket Island Chamber of Commerce, Martha's Vineyard Chamber of Commerce and the Arts Foundation of Cape Cod. Research and creative development were funded by the Massachusetts Cultural Council's John and Abigail Adams Economic Development Program and Barnstable County's Cape Cod Economic Development Council.

In addition to the partners and their staffs, other Cape & Islands organizations helped us recruit artists and inform the text of the publication. Those groups include the local Chambers of Commerce, our Art Societies, Associations, and Guilds, as well as the local Cultural Councils.

The partners also gratefully acknowledge the assistance and generosity of HandMade in America staff in sharing their model and their experiences, as well as our artists and artisans for helping identify other participants, creating the trails, and sharing the love of their work with those of us creating the guide.

Wendy K. Northcross
CCE, Chief Executive Officer
Cape Cod Chamber of
Commerce

Nancy Gardella
Executive Director
Martha's Vineyard Chamber
of Commerce

Clare O'Connor
Project Manager
Cape Cod Chamber of
Commerce

Jeannine Marshall
Executive Director
Coastal Community Capital

Margaret Van Sciver
President, Board of Directors
Arts Foundation of Cape Cod

Research Associates
Bonnie Coutu
Christina Bologna
Anna Walsh

Tracy Bakalar
Executive Director
Nantucket Island Chamber
of Commerce

Daniel Dray
Administrator
Cape Cod Economic
Development Council

Funded, in part, by the Commonwealth of Massachusetts, Department of Business Development/Massachusetts Office of Travel and Tourism.

TABLE OF CONTENTS

Whether you have come to Cape Cod and the Islands for the beach or the vistas, this guidebook is your link to the artists and craftspeople of the region, those who have been inspired to create their art here by the natural beauty and the laidback way of life. The region has long been a mecca for artists. Many of the people featured on these trails learned their crafts by way of apprenticeships and traditions passed down through many generations.

Exploring off-the-beaten-track sites and touring scenic, winding back roads in search of artist studios will lead you to discover a Cape Cod reminiscent of bygone days. These trails wander off the main roads and introduce you to people who have been honing their craft here for decades, and others who are new arrivals but who have chosen this place to create their art.

Following the trails in this book will introduce you to unique characters, people who love what they do and love sharing their work with visitors. There is the husband and wife team whose gallery doubles as an ecological statement; it is literally underground. There is an Italian candlemaker trained in the art of ceramics,

and a Swedish-born woman who transfers watercolors into textile designs. Nantucket scrimshanders etch delicate lines into ivory. A Yarmouth Port woman has mastered the historic craft of making sailor's valentines.
A glassblower has work in collections of six presidents and the Japanese Emperor. You will find a pewter crafter, world class bird carvers, basket-makers, jewelers who create one of a kind pieces, and renowned potters.

Explore and discover a very different Cape Cod, a truly Cultural Coast.

Map Legend Of Cape Cod*

✈ **AIRPORT**

✈ **PRIVATE AIRPORT**

🗼 **LIGHTHOUSE**

⭕ **ROTARY**

⛴ **FERRY**

🟫 **CRANBERRY BOG**

– – – **TOWN LINE**

NATIONAL SEASHORE

🌲 **STATE FOREST/
CONSERVATION LAND**

① Shining Sea Trail
See Page 18

② Old King's Highway Trail
See Page 38

③ String of Ports Trail
See Page 62

④ Sea Captains' Trail
See Page 78

⑤ Great Dunes Trail
See Page 102

See Page 123 & 143 for Islands

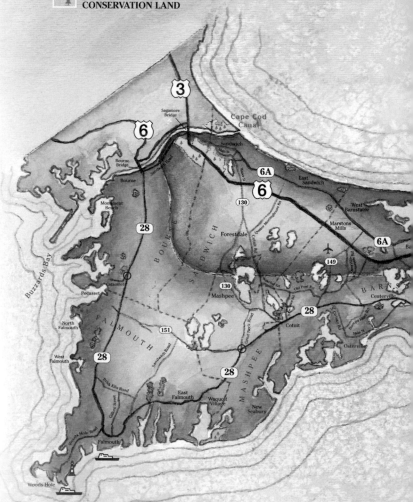

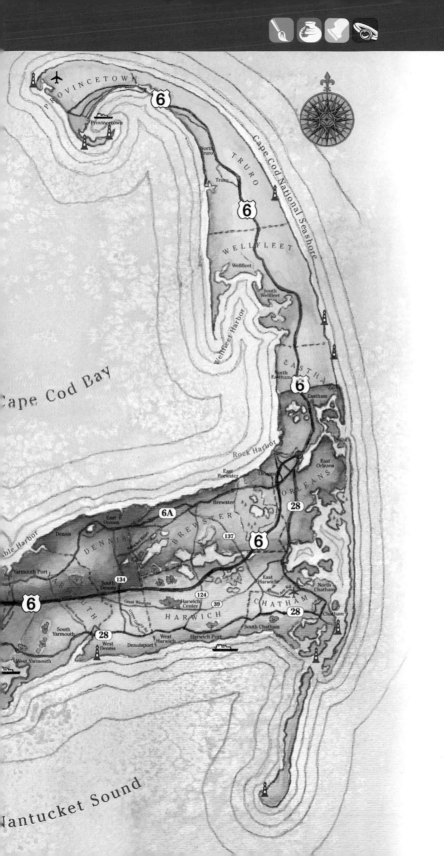

How TO USE THIS GUIDE

These seven itineraries have drives and walks to almost 200 stops. There is no set time for discovering the

arts on each trail, but don't plan on rushing through–you'll miss too many great artists and their stories. Remember, two of the trails are on islands, requiring boat or air connections. We have improved the trail maps in this second edition and numbered the stops, some with multiple studios and you can also look for the flags, banners, or window decals that tell you which studio or gallery is on the trail.

Pick a medium and follow it, explore a part of the region you're not familiar with. Visit the places you've been passing for years. You can reach some artists from bike trails and via shuttles in the summer. Walks to galleries in the harbor towns make delightful day trips. Many artists are open year-round, either by set hours or by appointment. If you visit in the winter, know that some sole proprietors take short vacations, and you may want to first call artists you particularly want to visit. The partners putting together this guide are more than happy to assist you before or when you arrive.

In Your Tote Bag	Bring along binoculars, Peterson's Field guides to birds, trees and wildflowers, sweatshirts for the cool evenings, shoes to toss off at the beach, picnic makings, sun creams, floppy hats, and a bag for your shells. And, bring your checkbooks since some studios are not set up for credit cards.

\mathcal{P}LANNING YOUR TRIP

Come ready to enjoy yourself.

Go with the flow The sea has a feel and scent all its own. The more slowly you go, the richer the experience. However long you think it'll take for you to do something, double it. Savor the experience.

Learn about the maker The real treasure is often the story behind the piece. The artists in this guide have stories, experiences and backgrounds that may not be found in the descriptions. Ask questions. Their work is a part of them. They like to talk about it. They have opened their workspace and work time to the visitor. Please respect posted hours for the sites, and remember that their time is precious.

Record your good times Whether you choose a notebook, sketch pad, camera or paints, recording your journey will allow you to revisit your experiences.

Call ahead about special needs If you or someone in your party has physical restrictions and needs special assistance, we strongly suggest you call ahead. Many studios are in private and antique homes, so handicap access varies considerably.

Pick up the phone Our regional artists live here to be surrounded by the abundance of natural beauty, both tranquil and inspirational. So, if the fish are biting or the light is perfect over the bay, especially in the late summer, they may flip their sign to "closed" to head to the water. Be forgiving. Use your cell phone if you are wandering far off your regular route. As many of them live and work in the same place, they are often available by appointment outside posted hours, particularly off season. If their listed times and yours don't mesh, give them a call.

LISTING CRITERIA

Town by town meetings on Cape Cod and one each on Martha's Vineyard and Nantucket drew in over 200 individuals to help us with the selection process. This included advising us on the criteria and offering sites for consideration. For this second edition, more artists joined us through recommendations from their colleagues. Criteria include:

- **Studios that offer dependable times for guests to visit, a minimum of 2 days a week for at least 4 months of the year**

- **Galleries that emphasize objects and paintings from the region, with priority given to artist owned galleries**

- **A willingness to share their love of their art with visitors**

- **High quality**

We double-checked each site against this and other criteria used to guide the artists on their decisions to participate. Staff visited each site personally to capture a sense of each place, and to engage the artists in our approach. Artists accepted into the guide agreed to a nominal processing fee to support the ongoing initiative. In this second edition of the trails and we have expanded the online presence at **www.capeandislandsartsguide.com** Telephone numbers, addresses, and other information are accurate as of the date of publication.

Finding More Artists

THERE ARE HUNDREDS OF ARTISTS in the region that are willing to see people by appointment but could not or weren't ready to open their studios for visitors in the timeframe we required. Many of them participate in open studios sponsored by art associations, or show their work in the art guild sidewalk shows in season that are not to be missed. As you wander on the trails go into the local Chambers of Commerce, or Town Halls, pick up the literature or buy the local news-papers and find these weekly or monthly events. Go on line at **www.capecodonline.com** for event listings, or visit **www.artsfoundation.org**. for their updates on openings and special shows.

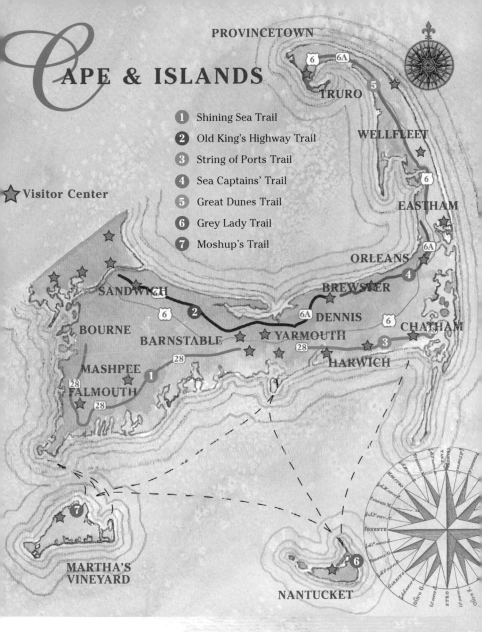

CAPE & ISLANDS

PROVINCETOWN

1 Shining Sea Trail
2 Old King's Highway Trail
3 String of Ports Trail
4 Sea Captains' Trail
5 Great Dunes Trail
6 Grey Lady Trail
7 Moshup's Trail

Visitor Center

TRURO

WELLFLEET

EASTHAM

ORLEANS

BREWSTER

SANDWICH

DENNIS

CHATHAM

BOURNE

BARNSTABLE

YARMOUTH

HARWICH

MASHPEE

FALMOUTH

MARTHA'S VINEYARD

NANTUCKET

TRAVELING IN THE REGION is easy, but takes planning. You arrive on Cape Cod over the Bourne or Sagamore Bridges, or by air into Hyannis. Ferries arrive in Provincetown from Boston in summer. Ferries leave year-round from Hyannis for Nantucket, in season from Harwich Port to Nantucket, year round from Woods Hole, Falmouth and seasonally from Hyannis area and New Bedford for Martha's Vineyard. There is also an in season ferry between the two islands. Both islands are served by air. We don't recommend taking a car to the islands, especially in season, when public shuttle busses or rental cars are plentiful. For short trips take the bike trails in all areas and prepare to walk around our beautiful villages. Pick up a Smart Guide or go to **www.smartguide.org** for complete public transportation information.

UR PARTNERS & TRAVEL RESOURCES

The Cape Cod Chamber of Commerce is a catalyst — a common vehicle through which business and professional people work together for our community's common good. The Chamber exists to do whatever is necessary to keep the area's economic condition at a level where businesses

will risk their resources here in hope of making a profit. Only by succeeding in this fundamental goal can we provide the jobs and produce the wealth to finance all the governmental, civic, educational, cultural and charitable needs that our community is faced with every day.

The Cape Cod Chamber of Commerce is dedicated to helping visitors to our region make the most of their vacation experience. Our professional, knowledgeable staff is happy to suggest accommodations, restaurants, transportation services, visitor attractions and more. Please visit one of our welcome centers during your stay on Cape Cod: the John C. Davenport Welcome Center at the Junction of Rtes 6 and 132 in Hyannis, the Rte 25 Visitor Center on Rte 25 Eastbound in Plymouth, or Rte 3 Eastbound in Plymouth. Call us at 888-33-CAPECOD or go to our informational website **www.CapeCodChamber.org**

The Nantucket Island Chamber of Commerce is the primary organization on Nantucket dedicated to promoting the interests of the business community. With nearly 700 members, the Chamber's mission is to foster Nantucket's economic vitality, while respecting the island's

unique quality of life, to the benefit of our membership and community. It is concerned with the viability and vitality of the historical, cultural, civic, environmental, and recreational features that position Nantucket as a premier visitor destination and provide a special way of life for its residents. The Chamber office is located in the heart of historic downtown Nantucket, upstairs at Zero Main Street, where staff is available to assist with all the questions that visitors might have. Come and peruse our extensive brochure racks, where you will find a bounty of information about our member business, activities, events, maps, and more. Please contact us at 508-228-1700 or visit **www.nantucketchamber.org**

The Martha's Vineyard Chamber of Commerce

invites you to visit the 50 plus galleries and artists' studios that dot the landscape of this beautiful island. Just a short ferry or plane ride from the mainland, the Vineyard offers exquisite examples of one-of-a-kind handcrafts, glassblowers, painters, jewelers, antiques and so much more! Cultural attractions abound, from the historic whaling town of Edgartown to the breath-taking clay cliffs in Aquinnah, home

of the Island's original people, the Wampanoag Tribe. Visitors to Martha's Vineyard have bountiful choices of fine dining with farm and sea to table cuisine and world class accommodations. Whether for the day, a weekend

getaway, or longer, the Vineyard experience is something you will cherish as much as the artistic memento you're bound to find. For more information, please visit us on Beach Road in Vineyard Haven, by phone at 508-693-0086, or online at **www.mvy.com**

The Arts Foundation of Cape Cod (AFCC) has strengthened and sustained the arts and cultural economy of Cape Cod since 1988. The Cape's designated nonprofit arts and cultural umbrella organization provides artists and cultural organizations with professional development, collaborative marketing, and financial support. The AFCC is the Voice of the Arts on Cape Cod and the key to its rich cultural landscape. Reach us at 508-362-0066 or visit **www.artsfoundation.org**

Coastal Community Capital is a community development financial institution providing millions in loan capital and technical assistance to those who create jobs and businesses. Coastal provided fundraising and fiduciary oversight to this project in support of our mission to stimulate economic development. Certified by the U.S. SBA and Treasury Dept. Coastal's core activities are providing loans and loan guarantees to promote business growth, and managing the EntreCenter, an entrepreneurial support center positioned to lend technical assistance to artists and

artisans and other businesses as their markets grow. Over the past decade and a half, Coastal Community Capital has been an important source of millions of dollars of new investment in the region, helping to increase employment opportunities resulting in wealth and income generation within our community. Call us at 508-790-2921 or visit us online at **www.coastalcommunitycapital.org**

Cape Cod Economic Development Council

(CCEDC) is an agency of Barnstable County consisting of 14 Council members appointed by Barnstable County Commissioners. The CCEDC promotes the creation of a healthy, sustainable economy by improving workforce skills, supporting regional infrastructure, fostering emergent industries, and encouraging education on a variety of issues for citizens, the workforce, employers, and public officials. The CCEDC provides grants for innovative projects that strengthen the Cape's year-round economy and collaborates with non-profit, public and private sectors on a variety of economic and workforce development initiatives. Grants have been awarded in support of marine science and technology, arts and culture, renewable energy, economic development planning, high-speed broadband planning, main street redevelopment, job readiness training, housing, marine fisheries, and commercialization of technology to name a few. Reach us at 508-744-1247 or at **www.capecodedc.org**

A WRITER'S PLACE

For more than 100 years, writers have been drawn to the Cape and Islands. Some have come for inspiration, others for relaxation. Still others are drawn by the camaraderie in a place that has long been a popular retreat for writers.

Contemporary writers like the late Norman Mailer and the late Kurt Vonnegut both lived on Cape Cod for years and wrote about this unique place.

But the Cape is also credited with giving inspiration to such giants of another era as playwrights Eugene O'Neill and Tennessee Williams.

Because Provincetown was the first place where one of O'Neill's plays was produced, the town lays claim to being the birthplace of modern American drama.

The Cape continues to be a place to see theatre at numerous venues, from the Provincetown Theater to WHAT (Wellfleet Harbor Actors Theatre) to Cape Playhouse in Dennis. There is also Highfield Theatre in Falmouth, Barnstable Comedy Club, Harwich Junior Theatre, Monomoy Theatre in Chatham and the Academy Playhouse in Orleans. The Vineyard Playhouse on Martha's Vineyard and Actors Theatre of Nantucket are also highly regarded.

In more recent years, the Fine Arts Work Center in Provincetown and Castle Hill Center for the Arts in Truro have attracted writers and poets like Robert Pinsky, among many others, to workshops and readings that are open to the public.

Martha's Vineyard has drawn scores of writers from Nathanial Hawthorne in the 19th century to the late novelist William Styron, who lived on the island for decades.

Nantucket also is a place popular with writers. In fact, the Nantucket Film Festival, held every year in June, is dedicated to the work of screenwriters.

To track down the works of local writers, head to one of the area's many fine bookstores, including independents, major chains, and antiquarian dealers. Most have sections devoted to the region and to local writers.

The Cape has also become somewhat of a mecca for aspiring writers. The Cape Cod Writers Center holds an annual conference at the Craigville Conference Center in Centerville, a charming beachfront enclave famous for its turn-of-the-century "gingerbread" cottages. The center also sponsors weekend writing sessions and writers groups. More information is available at www.capecodwriterscenter.org.

*T*he creative spirit runs deep in the Upper Cape towns of Bourne, Falmouth and Mashpee. There are lively arts centers in Bourne's Cataumet village and in Falmouth Center. Mashpee, known as the Land of the Wampanoag, is the ancestral home of the Cape's Native American population, who years ago called Cape Cod, "the Narrow Land." This trail also heads into the town of Barnstable to the villages of Osterville and Hyannis, the Cape's population center. In front of Hyannis Town Hall sits the statue of Iyanough, tribal leader of the Wampanoags, sculpted by Cape artist David Lewis. Taking detours is the key to enjoying this

trail. A trip to Osterville, for example, could include a visit to Armstrong Kelley Park, the Cape's oldest and largest privately-owned park, open free to the public. Osterville also has a Main Street ideal for strolling.

Woods Hole offers visitors a host of wonders. This is a historic fishing village with a bohemian bent, and several world-renowned scientific organizations have visitor centers open to the public. Falmouth's Main Street has art where you'd least expect it. The oversized bronze alphabet chair

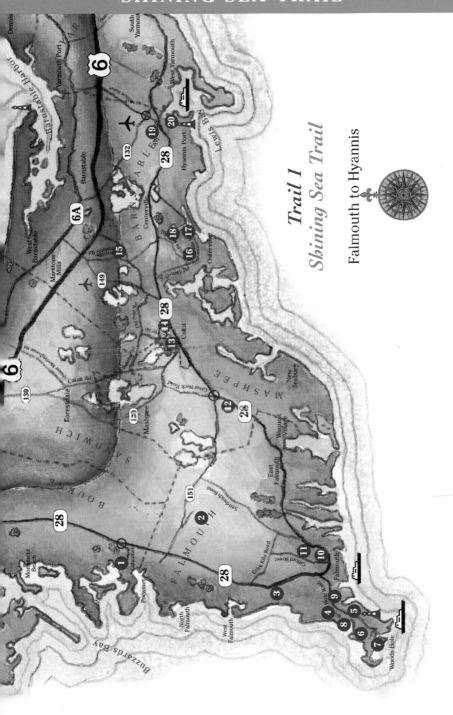

Trail 1
Shining Sea Trail

Falmouth to Hyannis

in front of Eight Cousins Bookstore looks like it's straight out of a Dr. Seuss book. And artist Sarah Peters has depicted historic industries of the region from ship-building to strawberry farming on bronze plaques on the sidewalk in front of the library lawn. In Falmouth, you can also bicycle along the coast on the Shining Sea Bikeway, named from a lyric in the song, America the Beautiful, penned by Falmouth native, Katharine Lee Bates.

How To Use This Trail

Cataumet Art Center, a little difficult to find off Route 28, serves as a good starting or ending spot for those traveling over the Bourne Bridge. Several of the locations on this trail – Woods Hole, downtown Falmouth and Osterville – make ideal half-day adventures. Consider visiting the Woods Hole artists on your way to or from the ferry to Martha's Vineyard, but make sure to leave time to enjoy their studios. A few artists are well hidden in residential areas. If you're creating your own trail, don't miss the directions in this guide. Break up the trail in Cotuit, with stops at the Cahoon Museum or Cotuit Arts Center, and then visit the more scattered galleries as you head into Hyannis's new arts district. Wind up at any of the great spots to dine in Falmouth, Mashpee Commons, Osterville, or Main Street in Hyannis.

Coming from the Bourne Bridge, take Rte 28 to the rotary. Take the first right to 28A-Cataumet. At the light, turn left. Follow the blue sign (on right) to Cataumet Arts Center. Turn right at the blinking light (approx. 2 miles) heading toward Pocassett. Bear left in .3 miles onto Scraggy Neck Road. Immediately after going under the bridge, turn right into P.O. Square and the Cataumet Arts Center.

CATAUMET ARTS CENTER - 1

76 Scraggy Neck Road - Year Round
Daily 9am-5pm, July-August 31st
September-June, 10am-12pm, Monday-Friday,
Saturday 10-5pm, Sunday 12-5pm
508-563-5434 • www.cataumet-arts.org

Located in a post and beam barn that used to operate as a general store, the Cataumet Arts Center displays a selection of fine arts and crafts by more than 40 local artists year-round. Artists and others in the community banded together to save the old building, beginning with Center Director Andrea York, who first rented the space as a painting studio. Another early renter was sculptor Alfie Glover, whose colorful, whimsical creations bring a touch of magic to the space. There are works in many types of media, including paintings, sculpture, photography, glass art, wood and metal work, and woven items. Frequently changing shows in the special Exhibition Gallery feature the work of individual artists or groups. Several artists have studios on the premises open to visitors. Classes and workshops for adults and children are offered year-round in painting, sculpture, photography, drawing, pottery, paper-making, beading and felting. Concerts, forums, and an annual indoor/outdoor artist fair are also scheduled.

Leaving the center, turn left under the railroad bridge on Scraggy Neck Road to the stop sign. Turn right, and then bear right onto 28A. Follow 28A 1 mile to a set of lights, and turn left onto Rte 151 until you get to Boxberry Hill Road (1.7 miles on right). Take a right on Boxberry Hill Road to Brady Drive. Take a right on Brady and an immediate left into the driveway - .7 miles. The studio is right behind the house, and the gallery in a small building at the other end of the yard. (Next page)

HATCHVILLE POTTERY - 2
494 Boxberry Hill Road - Year Round
July-Mid-October, Tuesday-Sunday, 10am-5pm
Other times by appointment
508-563-1948 • www.hatchvillepottery.com

In the quiet wooded neighborhood of Hatchville near Coonamessett Pond, Hollis Engley throws and fires his pottery. Hollis, a native of Martha's Vineyard, left a 25-year career as a newspaper reporter and photographer to make pots. His work is functional: pots for coffee and tea; bowls for oatmeal and stew. Good pots for good food. Hollis uses ash glazes made from ash collected from the wood stoves of friends, and other glazes influenced by Japanese traditional glazes. In the summer, visitors pass flower gardens on the way to the small shingled shed that houses Hollis's gallery.

Return to Rte 151, turning left. Go South toward Falmouth to the intersection of Rte 28, approximately 1 mile. Turn left and follow 28 about 6 miles to a traffic light with signs for Falmouth Hospital. Take a right at the light onto Ter Heun Drive and watch for signs for the main entrance to the hospital on left.

THOMAS E. HANLEY ART GALLERY AT FALMOUTH HOSPITAL - 3
Falmouth Hospital, Faxon Center
100 Ter Heun Drive - Year Round
Open when the Falmouth Hospital is open
508-495-0870

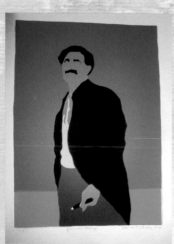

The Thomas E. Hanley Art Gallery is located in a long hallway outside the hospital's conference rooms. The gallery was established in 1988 by Mr. Hanley, and is run by the Hospital Auxiliary and coordinated by artist Muriel L. Henault Locklin. Mr. Hanley's screenprint of Groucho Marx is seen to the right. Twenty percent of money from the sale of paintings gets donated by the artist to the auxiliary. In addition to the gallery, the hospital has a permanent collection of 400 original works. This is one of the few local galleries that has single artist shows, six per year, as well as small group shows.

Returning to Route 28/Palmer Avenue, take a right at the traffic light. The road turns into Locust Street and then Woods Hole Road. Keep going straight, following the signs to Woods Hole, slightly over 2 miles. On the right, you'll see Quissett Studio Pottery, with the studio and gallery in a shed to the left of the 1860 sea captain's home.

QUISSETT STUDIO POTTERY - 4

319 Woods Hole Road, Woods Hole - Year Round
Daily, June-September, 11am-4pm
October-December, Thursday-Saturday 12-4pm
January-May, by appointment.
508-548-9943 • www.quissettpottery.com

Influenced by Early American and Oriental pottery, Anne Halpin works in stoneware and porcelain, striving for simple and fluid forms adapted for everyday use. Among her more unusual offerings are large platters like the one pictured here. Whether making clay or testing glazes, Anne's intentions remain the same: to lead a life defined and fulfilled by working at a traditional craft. Always searching for the beautiful glaze, the fine form, the useful pot, connects her to a long history of people who have made pottery at the side of a village road.

Turning right out of the driveway, continue travelling towards Woods Hole on Woods Hole Road. Immediately after the MBL Quisset Campus entrance, take the first left, halfway down on the left is #36.

FILM FESTIVALS: The Cape and Islands are a mecca for film buffs during three major film festivals that take place in the summer. The Woods Hole Film Festival begins in late July and focuses on first-time filmmakers or those with a local connection The Provincetown International Film Festival, in mid-June, is billed as a place to see original and independent films. The Nantucket Film Festival, also in mid-June, celebrates screenwriting.. To find out more information about any of these events, check out their websites at:www.ptownfilmfest.org; www.nantucketfilmfestival.org and www.woodsholefilmfestival.com.

REDFIRE STUDIO/ABSTRACT WORKS - 5
36 F. R. Lillie Road, Woods Hole - Year Round
June–mid October 11am-4pm Mondays and Tuesdays
Mid October-May Saturdays 11am-4pm
508-540-4345

Time and space, the themes of Max Redfire Wheeler's abstract paintings, seem to stand still as you look at his full walls and thumb through drawers full of his art. Redfire's life is art and poetry, and he does both with a wonderful energy and a warm, rich tone. Visiting Max gives you a quiet stop on your travels, with paintings, drawings, and monotypes that range from surreal to abstract. Allow time to linger in his writing room and browse through trays of award-winning poetry that you can take home as bookmarks.

Returning to Woods Hole Road, turn left and head into the village of Woods Hole and find a place to park. The next two galleries are right near the bridge, the first in the back room of Coffee Obsession, on the left side of the street at the intersection of Water Street and Woods Hole Road.

MARK CHESTER PHOTOGRAPHY AT COFFEE OBSESSION - 6
38 Water Street Woods Hole - Year Round
7 days a week when the Coffee Shop is open
For home studio call 508-299-8311 for appointment
www.markchesterphotography.com

Coffee Obsession's back room is full of Mark Chester's stunning black and white photographs, which have been published in the New York Times, Washington Post, Los Angeles Times and other major city papers. Mark photographed Charles Kuralt's book Dateline America, and created his own book, No in America, with serious and silly photographs of NO signs. His photographs are in permanent museum collections in Baltimore, Brooklyn, Portland, San Francisco, and more. For Mark, photography is always watching for the right moment, and this is seen in his pictures of people, places and things that have touched him in an emotional, intellectual, or whimsical way. Get a feel for his work at Coffee Obsession. To see more, call him—his home studio gallery is just a 15 minute walk away.

For the next gallery, cross the drawbridge and look on the left. Woods Hole Handworks is on the Lower level of the Community Hall, right on the water.

WOODS HOLE HANDWORKS - 7

68 Water Street, Woods Hole
Daily 10am-5pm,
June and after Labor Day to mid September
July-Labor Day Sunday-Wednesday, 10am-6pm
Thursday-Saturday 10am-8pm
Mid September to Columbus Day
Thursday-Sunday 10am-5pm
508-540-5291 • www.woodsholehandworks.com

Breath-taking views of Eel Pond and Vineyard Sound. Watch the sailboats and yachts pass under new draw bridge. This waterside gallery, Woods Hole Handworks, is a cooperative of more than 25 years featuring a wide variety of work from local and regional artists in textiles, prints, photography, glass, jewelry, ceramic tiles, and paintings Artists include Jano Fay Baker, Mark Chester, Tamara Clark, Karen Colburn, Jeri Dantzig, Vivian Vine Dreisback, Anna Galloway Highsmith, Ann Hanson, Sarah Morse, Judi Goudreau, Julia Peterson, Nicole St. Pierre, and Pat Warwick. And you'll always find an artist staffing the shop, sometimes working.

Leaving the village head back Woods Hole Road toward Falmouth. Across from the Fire Station, watch for the Flying Pig Pottery sign on the right. Enter the studio at the rear of the house.

FLYING PIG POTTERY - 8

410 Woods Hole Road, Woods Hole - Year Round
Thursday - Sunday, 10am-5pm
508-548-7482 • www.flyingpigpottery.biz

The pottery of children's book illustrator Tessa Morgan is unique. Tessa makes functional white stoneware decorated with dark blue sgraffito, a process of carving through dark colored slip to the light clay beneath. Her bold graphic designs feature both whimsical subjects: mermaids, flying pigs and cats dance across her pots, as well as images inspired by the natural beauty of Cape Cod. Unusual pieces such as sake sets carved with delicate designs are available.

Turning right out of Morgan's driveway, continue 1 mile and you'll see Ron Geering Pottery on the right. The house was converted from Old Hose House #3 of the Falmouth Fire Department and is registered with the Massachusetts Historical Commission. The studio and gallery are in a cozy cottage to the right of the house.

R. GEERING POTTERY - 9
246 Woods Hole Road, Woods Hole - Year Round
Tuesday-Saturday, 10am-5pm
508-457-0841 • www.geeringpottery.com

Ron Geering has been recognized as one of the top traditional craftsmen in American. He has traveled around England researching country pottery techniques for Plimoth Plantation, and this intensive research is reflected in his works. Interpreting traditional crafts in a contemporary way, he specializes in slipware and redware pottery. His works include exact reproductions of 17th through 19th century English and American wares as well as contemporary designs created with traditional slipware techniques. In recognition of his mastery, he was invited to create an ornament for the official White House Christmas tree.

Head into downtown Falmouth. Drive 1.8 miles north on Woods Hole Road. As it turns into Locust Street, look for the Inn at One Main Street on the right. Turn right past the Village Green and drive down Main Street. You can drive or walk the path to the two stops, which are off Gifford Street. From Main Street, turn left at the blinking light onto Gifford. Make a quick right on Occum Lane and look for the Glass Hut Studio.

COONAMESSETT FARM Visit the 20-acre Coonamessett Farm for a close-up look at one of Falmouth's last major working farms. In the summer, members pick berries, vegetables, herbs and fresh flowers. The farm store, ice cream stand and farm café are open most days for lunch in season and on some nights for special vegetarian buffet and Jamaican buffet dinners. Check out the farm's alpacas, sheep, goats, donkeys, chickens and ducks. You can even rent a kayak or canoe to explore Coonamessett Pond.

GLASS HUT STUDIO
14 Occum Lane, Falmouth - Year Round
Monday - Saturday, 11am-6pm
508-540-9179 • www.glasshutstudio.com

In a light-filled studio in Falmouth center, Andrew Ross makes stained and leaded glass windows, fused glass, etched glass, and dichroic glass jewelry. Andrew has his own unique designs on display, for example, his "Cape Cod plate" in which a blue-green outline of Cape Cod is fused onto a clear and teal fused background then "slumped" into a crinkle plate mold. Best-selling suncatchers include a sailboat made of five pieces of beveled glass with a port hole frame of sky blue and cobalt glass. He also sells stained glass tools for hobbyists.

Leaving Occum Lane and returning to Gifford Street, make a right, traveling about .2 miles and look for the Man on Fire sculpture, marking the Arts Center Entrance. There is adequate parking off the street.

MODERN DAY ART COLONIES
While Provincetown at the Cape's tip was renowned as an art colony in the 20th century, the entire Cape is becoming a draw for artists in the 21st century. In the Upper Cape, the Cataumet Arts Center has long been a gathering place for artists, with working studio space as well as galleries. Similar set ups exist throughout the region and on both islands. The art associations and guilds are impressive, both in number of members and their skills. If you want to take advantage of the wealth of hands on experiences in the region, look at the centers— and ask your favorite artist where they teach. It'll be mostly off season, but a great reason to

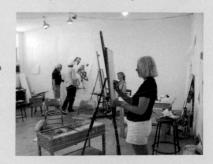

come back. Local artists form their own colonies, too. At the Cape's "elbow," Kely Knowles opens her studio in Rock Harbor each week to artists who want to paint together. When they have time, artists in Dennis Village visit each other as do the potters in Woods Hole for inspiration and support, linking their creative talents together in a way that adds a rich texture to our community.

FALMOUTH ARTS CENTER - 11
137 Gifford Street, Falmouth - Year Round
Tuesday-Friday, 9am-4pm;
Memorial Day-Columbus Day Saturdays 12pm-4pm
Weekend Workshops call to confirm
Closed all national holidays
508-540-3304 • www.falmouthart.org

The Falmouth guild, one of the Cape's oldest, began almost fifty years ago when a small group of painters got together and began informal art classes. Today the guild has over 300 members and a full range of classes, workshops, exhibits. The Falmouth Art Center is the new home of the Falmouth Artists Guild. The Guild offers art education and exhibition opportunities for all ages and abilities. Open year 'round; weekend hours vary during the year. There is always an art show to view whether in the main or lobby gallery, and the center is completely handicapped accessible. When an art class is taking place in the gallery, visitors are encouraged to view the class and the art show, and can always enjoy the grounds, in which many members do their plein air painting. A family friendly art center, children's programs and classes draw in both year round and vacationing students.

Leaving the Art Center, turning right onto Gifford Street, you will pass the Coonamessett Inn. Go almost 2 miles to the next set of lights, and turn right onto Brick Kiln Road. Turn left at the first light onto Sandwich Road. Turn right at light onto Rte 151 and travel around 3 miles to Job Fishing Road. At the light, turn right and go the short distance crossing Rte 28 and then entering the South Cape Village. Take the first right. Color Obsession Gallery is located in the central Courtyard, across from Heathers Restaurant.

COLOR OBSESSION GALLERY - 12

15 Joy Street, South Cape Village, Mashpee
Year Round
**Daily, July-August, 10am-6pm Monday-Wednesday,
until 7pm Thursday-Saturday
12pm-5pm Sundays
June and September, closed Mondays
October -May Tuesday-Saturday 10am-5pm
508-246-6246 www.colorobsessiongallery.com**

Gayle Morrow Olsson has created an experience where you Immerse yourself in color while viewing a variety of contemporary two and three dimensional art, jewelry and furniture in the several tableaux of the gallery, a real feast for the eyes and a pleasure for the soul. During the year, she uses the colors of the spectrum to feature individual artists from the gallery, like "The Responsibilities of Green" and "Seaing the Blues Show." Herself a stained glass artist, Gayle has created a varied range of workshops and demonstrations from her wide range of top established and emerging Cape Cod contemporary artists. This is a wonderful stop in the midst of South Cape Village, with great places to eat and relax.

Leave South Cape Village, turning right on Route 28 towards the rotary. Follow signs to Hyannis, and you'll see the Cahoon Museum on the left, just past the first traffic light.

WAMPANOAG: The Native American tribe, the Wampanoags, met the Pilgrims when they landed on Cape Cod in 1620. Legend has it that they helped them survive the first brutal winter. Hunting, fishing and agriculture have long been cherished by the tribe and are to this day. The Mashpee Wampanoag Pow Wow, every July 4th weekend, is open to the public and attended by members of tribes from all over the country. A tribe of Wampanoags is also based in Aquinnah on Martha's Vineyard.

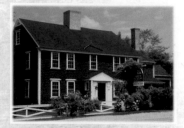

CAHOON MUSEUM OF AMERICAN ART - 13
4676 Falmouth Road/Route 28, Cotuit
Tuesday-Saturday, 10am-4pm,
Sunday 1pm-4pm
Closed January
508-428-7581 • www.cahoonmuseum.org

The Cahoon Museum of American Art is located in an impressively restored 1775 Georgian Colonial. The museum collection is focused on American art of the 19th, 20th, and 21st centuries and is the only comprehensive museum of American art on Cape Cod. It houses a choice collection of American marine paintings, landscapes, still lifes and portraits. The permanent collection is changed approximately every seven weeks. In addition, the museum mounts seven major exhibitions each season, so there is always something new to see. The museum extensively represents the work of Cape Cod-based artists and has a collection of record of the primitive paintings of Ralph and Martha Cahoon, the most famous folk artists the cape has produced, as well as the largest collection of noted contemporary cape artist

William Ross Searle. The museum is open six days a week throughout the year, except January. Art programs for adults and children are offered regularly. Please call or consult the museum web site for additional information.

Continuing east on 28 (left out of driveway), you'll find the Cotuit Center in less than 1/2 mile on your left.

COTUIT CENTER FOR THE ARTS - 14
4404 Rte 28 Cotuit - Year Round
Monday-Friday 10am-4pm
Saturday 10am-2pm
508-428-0669 • www.cotuitcenterforthearts.org

Founded in 1993 and incorporated as a non-profit charitable organization in 1995, Cotuit Center for the Arts (CCftA) has an excellent history of producing and presenting innovative, quality works that encourage individual artistic development and exploration. The Center also strives to increase awareness, understanding, and appreciation of the creative process by facilitating communication among artists and between artists and the public.

Over the last fifteen years, thousands of people have come through the doors of Cotuit Center for the Arts and experienced an art center unlike anything else. Offering programs and events such as critically acclaimed and sold out theatrical productions, on-going arts classes for children and for disabled adults, visually stunning art exhibitions representing school age artists to masters, comedy, poetry, theater camps for children, chamber music, Latin, blues, swing, jazz & rock music...

and so much more, the Center has established itself as a great place to celebrate the arts.

The range of CCftA's programming is vast. Internationally and locally recognized artists have appeared or had their works represented at the Center. Whether exhibiting works from a master or a preschooler's first encounter with watercolors, Pulitzer Prize winning plays or theater games for rising stars - diversity is the hallmark of CCftA's programming. The Center is a great place to visit and stroll through the gallery, take a class, or attend a play.

Turning left onto Route 28 out of the driveway, continue 2 miles to Osterville/Old West Barnstable Road. You'll see the White Hen on the left. Make a left at that light. Go one mile, just past Old Falmouth Road. Ron Dean's studio will be on your right. His studio, The Barn, is next to his house.

RON DEAN POTTERY - 15

1000 Osterville/W.Barnstable Rd, Marstons Mills
Year Round Thursday-Saturday, 10am-5pm Sundays
12pm-4pm • Other times by appointment
508-428-6085 • www.rondeanpottery.com

In the Barn, you'll find Ron creating pots of stoneware, porcelain and raku. Lined up along the walls are various creations of pots that Ron considers like family, all related yet individual and unique. Each piece is made by hand on the potter's wheel or by hand-building. The functional work is food-safe and can be used in the microwave and dishwasher. He also makes non-functional form-oriented pots using alternative firing techniques. Ron loves to share his experiences with the varied techniques used in production, making it a welcome stop for those who love pottery.

Turn left out of his driveway; go straight through stop sign about 1 mile to route 28. Cross over route 28 staying on Osterville/West Barnstable Road. Head into downtown Osterville, you'll be on Main Street. Just before you get to Osterville Center you will see Schulz Gallery on your left. His gallery has yellow shudders.

SCHULZ GALLERY - 16

898 Main Street Unit A Osterville - Year Round
May 1- September 1, Monday-Saturday,
10am-5pm, Sunday 11am-5pm
September 1 to May 1, Thursday-Saturday
10am-5pm, Sunday 11am-5pm
508-428-8770 • www.schulznatureart.com

Matthew Schulz grew up hunting and fishing the waters of Cape Cod with his grandfather. It was through this love of the outdoors that Matt began painting. As a young man, he was first attracted to wildlife art through the use of duck stamps. His love for the land and its creatures is translated to the viewer through his paintings. Matthew's paintings of Wildlife and Sporting art have garnered awards in Massachusetts, New Jersey and North Carolina, while his Landscapes have been part of both solo and group juried exhibitions including the Copley Society, Boston, Cahoon Museum of American Art, and Leigh Yawkey Woodson Museum,. The gallery features a fine selection of Landscapes, Wildlife and Sporting Art.

Leaving Schulz Gallery walk directly across the street to Joan Peters shop.

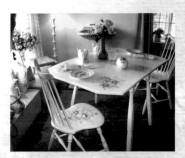

JOAN PETERS OF OSTERVILLE, INC. - 17
**885 Main Street, Osterville - Year Round
Memorial Day-Columbus Day Mon-Sat 10am-5pm
Rest of year, Wednesday-Saturday 10am-5pm
508-428-3418 • www.joanpeters.com**

Joan Peters is known primarily for her beautiful fabrics and wallpaper (all produced in New England), with hand designed toiles of scenes from Cape Cod, Nantucket, Martha's Vineyard and Boston, and Mermaid Toile as well as Nantucket Baskets and Hydrangeas. In her shop, you will also find Joan's paintings which complement her decorative objects. An artist and Interior Designer, Joan has created unique reminders of the Cape and Islands for the home with limited edition fabrics, wallpapers, and coordinating accessories, including tiles, hand painted lamps, sinks, pillows, and custom carpets.

Walk down Main Street. To the right is Birdsey, on Wianno Avenue.

"BIRDSEY" ON THE CAPE - 18
**12 Wianno Avenue, Osterville
Daily, Early May to Columbus Day
Weekend 10pm-5pm
Closed until week before Thanksgiving
Daily, Thanksgiving week through December 31
11pm-4pm
508-428-4969**

Look for the pink awning and the bounty of flowers in front of the delightful "Birdsey" on the Cape. The Bermuda artist, whose unique paintings captured a singular light mood, is the namesake artist of this gallery set in a historic cottage in the heart of Osterville center. When this gallery opened, twenty five years ago, they sought to show Cape artists as well as the "Birdsey's". They now represent 40 plus artists, offering a wide variety of style, media and price.

Leaving Osterville, follow Main Street toward Hyannis. You will see Wimpy's Restaurant on your left. Continue over the Centerville River. Turn right at the stop light (Four Sea's Ice Cream on your left). Go past Craigville Beach and fork to the right to turn on Smith Street. At stop sign turn left onto Scudder Road. At rotary follow signs to the Hospital, you'll be on South Street. Look for the Guyer Barn right before Town Hall.

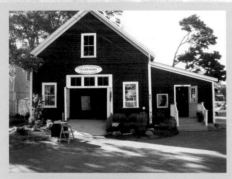

You're just steps off of Hyannis Main Street and among a strand of galleries and artist work spaces along Pearl Street. The campus includes the historic Guyer Barn, serving as a community art space with year round schedule of art The Guyer Barn serves as a community art space with year round schedule of art classes and workshops in a variety of media coupled with artist exhibitions from new, emerging talent and student works to well known established artists. Class and exhibit information is available online at harboryourarts.com.

To the left of the Barn, walk through a path to get to the Shirley Blair Flynn Center for the Creative Arts, a modern day art colony with Town owned properties at the corner of Pearl and South Streets in Hyannis, providing artist living, work and gallery space. 50 Pearl has a rich history as a gathering place for local artists. Playwrights and poets congregated at the home for lively readings and nautical themed original Vernon B. Coleman murals decorated basement walls. A few of the resident artists are highlighted below.

c.a. danner WORKING ARTIST STUDIO - 19
Shirley Blair Flynn Working Artist Studios
50 Pearl Street, Hyannis - Year Round
Daily, 2pm-6pm
Other times by chance and appointment
508-737-4536 • www.caroleanndanner.com

Carole Ann Danner is well known for her portraits, with a new series focused on seniors. She gives life and a voice to these extraordinary 70, 80-and 90-year old women in a series called "Mothers, Aunts, and Grandmothers." Inspiration for her imaginary landscapes comes from living on Cape Cod, and pushing nature to the extremes of line, form, shape, color, and texture. Her latest chess pieces are in encaustic, in a grid-like format. All of her work explores the relationship of forms and color with an interest in play. She values art that moves her physically and emotionally. In addition to this, her working studio, she also shows at the Breakdown Lane gallery in Hyannis and the Harvest Gallery in Dennis.

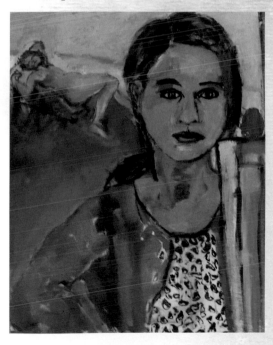

In the same building, you'll also find Melanie Chartier.

MELANIE CHARTIER STUDIO - 19
Shirley Blair Flynn Working Artist Studios
50 Pearl Street, Hyannis - Year Round
Tuesday-Saturday 11am-2pm
Or by appointment
508-685-2001 • www.melaniechartier.com

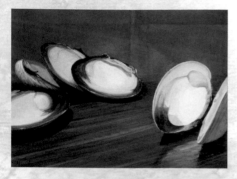

Walking into Melanie Chartier's working studio, you are surrounded by an array of work all that engages the viewer in new ways. Known for her "Big Shells", Melanie feels that getting up close and personal with a small shell is not the same as a small shell getting close to you. Like her other still lives, her paintings have a narrative quality, with iconic items placed together like actors on a stage, Her themes revolve around the relationships these items have—connection, group identification, trust, and intimacy. Melanie gives the viewer a new and energetic way to look at still lives, and her engaging personality makes this a great stop in the new Arts Disrict.

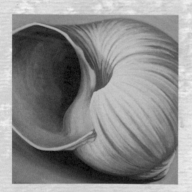

MAIN STREETS: A stroll down Main Street in Hyannis will take you past countless restaurants, shops, and, of course, art galleries. Don't miss the John F. Kennedy Hyannis Museum at 397 Main Street in the old town hall. The museum's multi-media exhibit featuring over 80 photographs is designed to open a window into the days the former president spent on Cape Cod. While on Main Street, look for the village green where you can sometimes find band concerts, art shows and other community events, including the Annual Pops by the Sea concert sponsored by the Arts Foundation of Cape Cod.

HARBOR YOUR ARTS
AND ARTIST SHANTIES - 20

Other artists are nearby: Sarah Holl paints at Artspace at 46 Pearl Street, In addition to Melanie Chartier and Carole Ann Danner, artists at 50 Pearl include Molly Driscoll, Deborah Donovan, Jenny Fragosa and Ken Gavin work with a variety of mixed media-from oils on wood, canvas and encaustics, to printmaking and painting, mono type prints and clay. Visitors will relish in hearing the artists stories and watch them create a work in progress.

Steps away from Pearl Street one can follow the Walkway to the Sea, the pathway that runs from Hyannis' Main Street to Hyannis Harbor; a bustling place with ferry boats traveling to Nantucket and Martha's Vineyard, charter fishing boats and sightseeing vessels. There are seven artist shanties along the harbor front which are summer artist studios of local, juried fine artists and artisans who create, display and sell their work. The shanties provide a picturesque setting to view art made by both man and nature. Visitors to the seven harbor side shanties can chat with artist about their work and watch the creative process as the local artists take their inspiration from the harbor. The shanties offer a myriad of art from photography, paintings, handmade jewelry, rope work, jewelry and much more. Shanties are open from May through Columbus Day. And, as you walk back to Main Street, look to the right on South Street for the Cape Cod Maritime Museum.

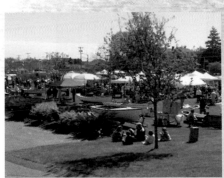

Also in downtown Hyannis are Artscape Thursdays, the first Thursdays of each month starting in May. In addition to open studio events, local restaurants have special offerings to make your evening complete.

*F*ollowing the Old King's Highway is a little like going back in time. The winding, narrow road, also known as Route 6A, stretches for 34 miles parallel to Cape Cod's northern shore. It passes through seven villages from Sagamore to Orleans on its way to the Lower Cape, and on this trail, you'll travel through five of them. Scores of artists and craftspeople make their homes along the route and welcome guests to see their work.

Route 6A is the old stagecoach route, virtually unchanged for more than 200 years. Drivers along the route, considered one of America's most scenic roads,

pass hundreds of historic houses, vistas of salt marshes, and numerous quaint shops, restaurants and inns. Originally a Native American path, the route began to be developed in the 17th century as sea captains built their homes close to the harbors. The stagecoach brought visitors down from Boston who required lodging and services. Among those was Henry David Thoreau, who felt the bumpy, long trip was a most uncomfortable ride. It wasn't until the early 19th century that the road was paved.

The trail begins in Sagamore at Pairpoint Glass, one of the country's oldest glass works. It continues through Sandwich, the Cape's oldest town, founded in 1637. Sandwich has a host of interesting historic sites,

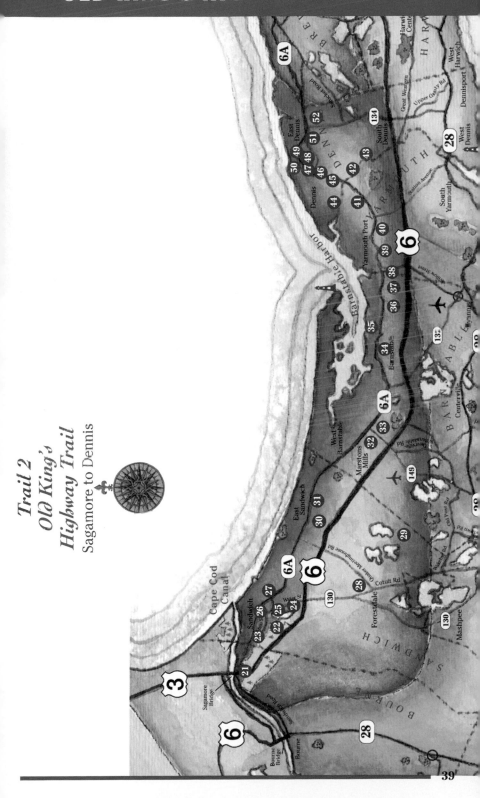

Trail 2
Old King's
Highway Trail
Sagamore to Dennis

including the Sandwich Glass Museum, the Heritage Museums and Gardens, and the Green Briar Nature Center and Jam Kitchen. The route passes through the two charming villages of West Barnstable, with its stone walls and ancient cemeteries, and Barnstable, where the austere granite courthouse signifies the seat of Cape Cod's county government. Next, drivers pass through the village of Yarmouth Port, which has two noteworthy historic house museums, the Bangs-Hallet House and the Winslow Crocker House, as well as the unique Edward Gorey House. The last stop on the trail, Dennis Village, is the location of the Cape Cod Museum of Art, as well as the Cape Playhouse and Cape Cinema.

How To Use This Trail

Plan this section like a stagecoach ride: plenty of stops and more than one day. There are lots of B & B's and inns to extend your stay, restaurants–or vistas for picnics–to break up the trip. In the villages of Sandwich, West Barnstable, Yarmouth Port, and Dennis, artists are clustered and know each other well. The itinerary keeps you heading east along 6A. Take advantage of the summer art walks in Dennis, or the open gallery events in Sandwich. You might start your tour with a historic perspective in Sandwich at either Heritage Plantation or the Glass Museum, then visit the artists to see their interpretations in glass, jewelry, pottery, or painting. Don't miss the unique offerings in the galleries with multiple art forms. And, be sure to take the detours off 6A for some fabulous art and great conversations you might have missed without this guide.

Old King's Highway Trail

This trail starts right under the Sagamore Bridge at Pairpoint Glass. Coming from the Mid Cape Highway towards the bridge get off at exit 1. Take the first left (Adams Street) to the stop sign, turn left. Before the Citgo Station go into Pairpoint Glass parking lot.

PAIRPOINT GLASS - 21
851 Sandwich Road, Sagamore-Year Round
Monday-Saturday, 10am-5pm; Sunday, 11am-5pm
January- March, 10am-5pm Closed Sundays
800-899-0953 • www.pairpoint.com

Pairpoint, the oldest operating glassworks in the United States, is located in the shadow of the Sagamore Bridge. Founded in 1837 in South Boston as the Mt. Washington Glass Company, the business merged in 1894 with Pairpoint Silver Company. These days, Pairpoint are world-renown makers of hand-blown and handmade traditional and contemporary glass and crystal. At this combination showroom and glass factory, you can look through the large plate glass window and actually watch the pieces being made. There are wide ranges of items, from sun catchers to ornaments, to candlesticks and vases. Much sought-after are items made of the deep, richly colored cranberry glass. Glass-blowing demonstrations are Monday through Friday.

Make a left leaving their parking lot, driving away from the bridge. In 1.1 miles, turn right onto Rte 130 South (also Main Street).Turn right on Pine Street and go .6 miles to the Heritage Museum & Gardens. (Next page)

GLASS MAKING CRAFT: Creating hand-blown glass starts with heat. The artisan melts the glass to a liquid-like substance. Then the glass blowing begins. The artisan blows through a long, hollow rod, turning the mass into a vessel. Constantly turning the piece, he then shapes the form using a tool that stretches it and another tool that fine-tunes the shape. He heats the piece constantly in a furnace at more than 2,000 degrees to keep it hot enough to mold.

HERITAGE MUSEUMS AND GARDENS - 22
67 Grove Street, Sandwich
Daily April 1-October 31, 10am-5pm,
January-March, by appointment or program registration
Adults $12, Children $6, Seniors $11
508-888-3300 • www.heritagemuseumsandgardens.org

A variety of collections, from antique cars to toys to scrimshaw, even a vintage carousel, are on display at this unique museum of Americana, located on an enchanting 100-acre estate once owned by Charles O. Dexter. Dexter, the original owner, was famous for the cultivation of beautiful plants. The collections were the passion of museum founder Josiah K. Lilly III and his father, Josiah K. Lilly Jr. A replica Shaker round barn displays 35 antique and vintage cars, but rare cars are just the beginning. The American History Museum, housed in a replica of a Revolutionary War building, displays the collections of hand-painted military miniatures, Crowell bird carvings, and a seasonal exhibit Going Places about horse-drawn transportation. The Art Museum features a Folk Art Gallery, a 1912 Charles I. D. Loof working carousel and seasonal exhibits. When exploring the museum grounds look for the Hart Family Maze Garden, the award winning Dexter rhododendrons, as well as the hosta, daylily, and new windmill gardens. The rhododendrons bloom Memorial Day to mid-June, while over 1,000 hybrid daylilies bloom from mid-July to early August. More than a thousand varieties of trees, flowers and shrubs are on display. Also on the grounds is the Old East Mill built in 1800, a Museum Store and seasonal Carousel Café. The museum hosts many special events, car shows, lectures, workshops and family events for all ages and interests, and celebrates its 40th Anniversary in 2009.

When leaving the parking lot, where the road forks, stay to the right on Grove Street. It will be just under 1 mile to the center of town. Sandwich Glass Museum will be across the street.

SANDWICH GLASS MUSEUM - 23
129 Main Street, Sandwich
February-March, Wednesday-Sunday, 9:30am-4pm
Daily April-December, 9:30am-5pm
Closed January, Thanksgiving,
Christmas Day and New Years
508-888-0251 • www. Sandwichglassmuseum.org

The Sandwich Glass Museum combines exhibits of its extensive collection, including 5,000 pieces produced at the Boston & Sandwich Glass Company, with cutting-edge technology. At the dawn of the Industrial Revolution, the Boston & Sandwich Glass Company produced the finest pressed glass the world had ever seen, leading the world in the manufacture of glass well into the 19th century. A multi-media theatre show brings the history of the company and life in rural New England in the 18th and 19th centuries vividly to life. Fifty spectacular antique lamps light up one by one in the Levine Lighting Gallery, which displays a history of glass lighting devices from 1825 – candles to whale oil to kerosene – up to the point when Thomas Edison invented the electric bulb. In the Color and Chemistry Room, visitors learn about James Lloyd, the factory chemist, and his secret batch book. Every half-hour, visitors are invited to watch glass-blowing demonstrations in which molten glass, drawn from the furnace is blown and pressed into exquisite shapes. The Hannah "Rebecca" Burgess Dinning Room c. 1880, is the Museum's newest exhibit. It offers a rare glimpse into the life of a charismatic person and elaborates on the importance of glass objects manufactured by the Boston & Sandwich Glass Co. Special lighting makes the glass objects come to life.

Leaving Sandwich Glass Museum follow the signs to Route 130 South. In .9 miles on the left will be Gayle Niebaum Studio. You will see her sign. The house and gallery are set back and located in a rhododendron farm. (Next page)

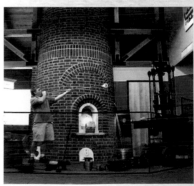

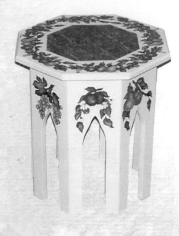

GAYLE NIEBAUM STUDIO - 24
59 Water Street (Rte 130), Sandwich
June-October, Wednesday-Saturday, 10am-4pm 508-888-5252

Gayle Niebaum creates hand-painted furniture and accessories in a converted garage that she has turned into her work space and gallery. The magical setting is a rhododendron farm. The magic continues in the work shop where Gayle takes new furnishings or beloved family treasures and turns them into hand-painted heirlooms. There are sea chests with intricately macramé handles, cabinets painted to match a china pattern, as well as vanities, tables, chairs and more, decorated in trompe l'oeil and faux finishes, like marble, leather or crackle.

Leaving Gayle's Studio turn right on to Route 130, passing the Hoxie House, the oldest house on Cape Cod. Across from Shawme Pond and the Thornton Burgess Museum on your right is Shawme Pond Pottery.

SHAWME POND POTTERY - 25
7 Water Street, Sandwich
April 15th-December 24th, 10am-5pm
Other times by appointment
508-888-4622 • www.capecodpotters.com

In one of the oldest houses in Sandwich right across from Shawme Pond, Shawme Pottery is the home and workshop of Margaret Tew Ellsworth. Margaret gathers her inspiration from the beautiful gardens and the woods that surround her studio. Creatures from rabbits to chameleons adorn her cache-pots and ovenware; leaves from the wild grapevine appear on the tableware. She is known for beasties and mythic figures, including the leaf-faced "green man," whose face appears on planters, pitchers and fountains. Also displayed are her watercolors and oil paintings of marshes, flower gardens and the surrounding seas and her jewelry.

Leaving Shawme Pond Pottery, turn right toward the center of town. Bear right at the First Church of Christ toward Main Street. Turn left on Jarves Street. Right next to the Belfry Inn you'll find My Sister's Gallery, with the Collections Gallery across the street. Both have a wide variety of fine art and objects.

MY SISTER'S GALLERY - 26
20 Jarves Street, Sandwich - Year Round
daily 10am-5pm
508-888-0756 • www.mysistersgallery.net

My Sister's Gallery offers a diverse and continually-varying selection of gifts for you and your home. From paintings, limited giclee prints, a wide range of hand-blown glass, expertly crafted pottery and hand-crafted jewelry there is sure to be a delightful assortment to please any art palate. Created by Donna Bridges to showcase the many talented artists residing on and around Cape Cod, the Gallery, opened in 2005, exhibits a growing collection of over 100 regional artists. Donna and Justin, her son and partner in the business, have an eclectic sense of taste and love talking to visitors about all their artists.

COLLECTIONS GALLERY - 27
23a Jarves Street, Sandwich
March-December, Daily 10am-5pm
Call for January and February hours
508-833-0039 • www.CollectionsGallery.com

In their eighteenth year, Collections Unlimited has moved from Rte 6a uptown to Jarves Street and is now Collections Gallery. Their high white walls are covered with wonderful artwork and photography. Shelves and glass cases contain jewelry, pottery and woodworks. The cooperative includes jewelers, potters, a basket maker, and more. They have stained glass, painted furniture, baby gifts, cards, soaps, floral arrangements and several styles of handbags and designer clothing. With an ever changing membership there is always something new to see. Visit often. Every time you come you will meet a different artisan.

Continue travelling along Jarves away from town, turning right onto Route 6A. On the right, you will see Green Briar Nature Center and Jam Kitchen. The next two artists are located a little off the beaten path, but well worth the drive. Travel 6A east 1.8 miles to Quaker Meeting House Road, and stay on that road approximately 2.5 miles to a stoplight. Turn right onto Cotuit Road, then right into the driveway for McDermott Glass, across from Bayberries Restaurant. You can always find these glass artists in the large studio in the rear with open doors; the gallery is in the back of the house. (Next page)

GREEN BRIAR NATURE CENTER AND JAM KITCHEN:
6 Discovery Hill Road, East Sandwich
Admission by donation.
Mid April to December, 10am-4pm, Sunday 1-4pm
January to Mid April Tuesday to Saturday 10am-4pm
508-888-6870 • www.thorntonburgess.org
Along the shores of Smiling Pool and adjacent to the briar patch where Peter Rabbit got into mischief, is the 57-acre Green Briar Nature Center and Jam Kitchen. The site is part of the Thornton Burgess Society's holdings in the town of Sandwich. Thornton Burgess, an author and naturalist, chronicled the tales of Peter Rabbit in 170 books. The nature center offers nature trails, gardens, and an interpretive nature center. In the adjacent jam kitchen, they have been churning out jams and jellies since 1903.

MCDERMOTT GLASS STUDIO & GALLERY - 28
272 Cotuit Road. East Sandwich - Year Round
Gallery: 10am-6pm; Closed Wednesday
Studio: (Glass-blowing)
10am-6pm, Thursday-Saturday
508-477-0705 • www.mcdermottglass.com

David McDermott has created one-of-a-kind glass pieces for six US Presidents, Pope John Paul II, and the Empress of Japan. His journey in glass-blowing began over 30 years ago at Pairpoint Crystal, under the tutelage of Master Gaffer Robert Mason, in the tradition of generations of Scottish masters. The vibrant colors and unique shapes infused in his art glass are unforgettable. Conversing with David as you wander along the glass-lined path from gallery to studio, you'll experience a love and deeper understanding for this age old craft. David's wife, Yukimi Matsumoto, studied glass-blowing in Japan and has a well deserved reputation of her own. She is best known for her soft design lines and impeccable color selection, giving her work a feeling of nature. Check their website for their annual Glass Jams, bringing in glassblowers from all over the country, open to the public.

Coming from McDermott Glass go back to the light and continue straight on Cotuit Rd. At the white marker for Farmersville Rd (2 miles), turn left. In less than 1/2 mile, there is a junction with Race Lane and Newtown Rd; bear right onto Newtown Rd, pass the Ridge Club on your right. Go approximately .2 miles and look for the oval white sign on the right for Susan Davies studio.

SUSAN DAVIES CUSTOM TILE AND FINE ART - 29
23 Newtown Road, Sandwich - Year Round
July-Oct; Friday and Saturday 10am-5pm
Other times by appointment and special events
774-238-2980 • www.susandaviesartist.com

Look for the sign to Susan Davies studio and gallery, but don't trip on the chickens as you walk through the yard! Original oils, hand painted tiles fired in her kiln, and giclee prints grace a delightfully lit studio attached to her house. Specializing in botanical designs and landscapes, Susan's work space is surrounded by window boxes and a large vegetable garden. A plein air painter, Susan creates landscapes, florals, maritime themes, and custom creations on tiles that are installed in bathrooms and kitchens throughout the region, bringing local or favorite scenes right into the home. Her work reflects her calm, soothing personality, putting the viewer in a positive place.

Now you'll backtrack to Rte 6A, reversing the directions. You'll continue east by turning right on 6A. In .7 miles on your right is Damselfly Studio, a gray cottage and gallery.

DAMSELFLY STUDIO - 30
412 Route • 6A East Sandwich - Year Round
Wednesday through Sunday 11am-5pm
508.888.5325

Karyn Frances Gray, a botanical artist and illustrator, has worked in several media depicting the flora of Cape Cod. Starting in 2009, Karyn embarked on a large project to catch the overlooked bits and pieces of reeds, grasses, seed pods, and twigs in fields and dunes. Especially in autumn and winter, these beautiful objects show their skeletons and beg to be drawn in sepia and ochre tones. Her studio is attached to her home and the works have reached out to fill every room. Karyn received her first drawing lesson from a favorite uncle as a small child. Her paintings have been displayed by the Smithsonian and many other venues. She is a member of the Cambridge Art Association.

One half mile after Damselfly Studio you will see a red mail box with a beautiful decorative glass post on your right. This will be the Glass Studio of Cape Cod. (Next page)

THE GLASS STUDIO ON CAPE COD - 31

470 Route 6A, East Sandwich - Year Round
Daily 10am-5pm July-August and
Thanksgiving-Christmas
September-November & January, Closed Tuesday
Other times by appointment
Glass Blowing Thursday-Sunday
508-888-6681 • www.glassstudiooncapecod.com

Glass artist Michael Magyar takes the ancient art of glass blowing and makes it modern and classic at the same time. His signature line is the Cape Cod Sea Bubble Collection, in which bubbles are infused within the swirls of cobalt blue and emerald green glass in a technique he learned in Japan. Michael's wife, Kieko, manages the gallery. The studio where the glass-blowing takes place is around the back, past a concrete and cast glass moon bench. In the workshop, all the tools of the glass blowing trade hang on the walls and the furnace is always going.

Leaving the Glass Studio on Cape Cod go a little over 4 miles east to the intersection of Route 149/Meetinghouse Way, where a number of artists are clustered. Turn right and on the right you'll see Anne Boucher's studio, in the same building as the Old Village Store.

ANNE BOUCHER FINE ART - 32

Old Village Store, Rte 149, West Barnstable
Year Round Fri and Sat, 11am-6pm or by appt.
Visit web for extended Summer hours
774-238-2859 • www.anneboucherfineart.com

Located in the 128-year-old historic Old Village Store in the heart of West Barnstable, Anne's studio/gallery displays her landscapes, seascapes, figure and still life watercolors and acrylic paintings. She also offers limited edition giclee prints as well as cards. Boucher's method begins with much exploration on foot, bike, and kayak. You may see her painting near the marsh at low tide, but often she'll be working in her studio. With her paintings hanging in the permanent collections of most of our area's museums, Anne is known for her light-filled, highly developed watercolor and acrylic paintings.

*Several houses further south on Rte 149 you will see a sign for West
Barnstable Tables on the left, in a large barn set back from the street.
Here two very different and highly regarded furniture makers work on
two levels of the same barn:*

WEST BARNSTABLE TABLES - 33
**Route 149, West Barnstable - Year Round
Daily, 9am-4pm
508-362-2676 • www.westbarnstabletable.com**

The color, texture and patina of old wood
cannot be reproduced. It is these qualities that are
highlighted in many of the unusual pieces at West
Barnstable Tables, where old wood is turned into
functional furniture and works of art. Founder Dick
Kiusalas builds easy-to-live-with, creative
furniture from old wood and other materials that
could be salvaged from antique buildings, boats, pianos,
wagons, whatever. The showroom also includes works by craftsmen
who make contemporary furniture from new hardwoods like cherry,
birds-eye maple and black walnut.

MORAN WOODWORKS - 33
**Lower Gallery at West Barnstable Tables
2454 Rte 149 W. Barnstable-Year Round
Mon-Fri 9am-4pm
12pm-4pm most Saturdays and Sundays
508-221-0081 • www.moranwoodworks.com**

Rick Moran likes to create furniture that gives
good karma. And that's what you'll feel when
walking into his shop. The clean lines of his tables
show the Shaker influence of timeless design with a
contemporary flair. For 30 years, Rick has been
hand making furniture with elegant, clean, and simple lines from solid
American hardwood, selected for quality, straightness, color, grain,
and beauty. Specializing in custom made tables and cabinets, he and
his assistant Scott Harvey work on the other side of a glass window
with a variety of hand and power tools. In addition to tables with fin-
ishes "smooth as silk," Rick also has beautiful men's vanities, mirrors,
and cutting boards.

*Go back to 6A. At the next intersection, Rte 132, you can take a short
detour to Cape Cod Community College and visit the Higgins Art Gallery,
within the Tilden Auditorium. As you leave the college, turn right at the
stop sign and right onto 6A. Head into Barnstable Village, passing the
Courthouse on the right. Just past the firehouse, also on the right, is
Barnstable Pottery Art Gallery. (Next page)*

HIGGINS ART GALLERY: Cape Cod Community College is a rich cultural center offering experiences that challenge the mind and excite the senses. The Higgins Art Gallery has seven varied exhibitions annually. Open weekdays from 10am-4pm, September to May, it displays a wide array of painting, sculpture, prints, crafts, and mixed media. "Brown Bag" presentations on Thursdays feature lecturers and visiting artists. The central campus is a sculpture garden with unique structures placed among the trees and walkways. More information about the Gallery and its shows throughout the year can be found at: http://www.capecod.edu/web/higgins

BARNSTABLE POTTERY ART GALLERY - 34
3267 Main Street, Barnstable Village - Year Round
Memorial Day-Labor Day, Tuesday-Sunday,
10am-6pm, Off-Season, 10am-5pm
508-362-1113

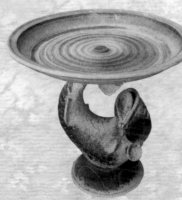

At Kevin Nolan's pottery gallery, visitors commingle with the work and creative process. In fact, conversation from visitors plays an integral role in this potter's philosophy and design. The gallery is a friendly, open space where questions are encouraged. His potter's wheels are positioned at the front of the studio, so he can watch the comings and goings on busy Route 6A. Kevin's Bassett hound Bourbon mostly sleeps at the entrance, surrounded by small sculptures, fountains and pagodas. Additional parking is next door behind the firehouse.

Continue about .4 miles from Barnstable Pottery and on a hill to your left you'll see a sign for the Cape Cod Art Association.

Cape Cod Art Association
Fine Art Since 1948

THE CAPE COD ART ASSOCIATION - 35
3480 Route 6A, Barnstable - Year Round
Monday-Saturday, 9am-4pm; Sunday 12-4pm
508-362-2909 • www.capecodartassoc.org

The Cape Cod Art Association, founded in 1948, has more than 1000 members, including prominent Cape Cod and New England artists. Numerous programs and events occur throughout the year, including 15 exhibitions of new works in the association's three art galleries. The gallery gift shop displays paintings, cards, and limited edition prints. Classes and workshops are scheduled year-round. The association also sponsors the Art in the Village Festival every spring in the heart of Barnstable Village. The festival includes a silent auction, children's activities, a raffle, sidewalk artists and art demonstrations.

In .8 miles at the corner of Mary Dunn Road, turn right, and go into the driveway immediately on the left for Mary McSweeney's studio and gallery. You're now in Cummaquid.

MARY McSWEENEY IRISH ARTIST
3885 Route 6A, Cummaquid - Year Round
May-October, 10am-5pm,
Daily except Wednesdays
November-April 30, by appointment
508-362-6187 • www.marymcsweeney.com

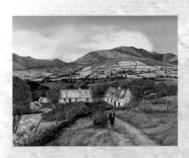

 People on both sides of the Atlantic call Mary McSweeney's oil paintings, "Irish to the core." Mary, who was born and raised in Killarney, Ireland, takes as her subject matter scenes of Irish life, the landscapes, the people, the customs. She travels back to Ireland frequently to paint and sketch. She'll tell you in her soft Irish accent that she captures what she sees with her brush, and her fond familiarity of the subject breathes life into the paintings. Mary's gallery and studio are attached to her house, with the gallery entrance on Mary Dunn Road.

Travelling about a half mile on 6A you'll see the Samuell Day Gallery on your right.

SAMUELL DAY GALLERY - 37
4039 Rte 6A, Cummaquid - Year Round
Tuesday-Saturday 10am-6pm
508-362-0175 • www.samuelldaygallery.com

Located on the second floor of a historic barn, Samuell Day Gallery features finely crafted blown and fused glass art, sculpture, vases, jewelry, paperweights, stained glass, garden art, little luxuries, and whimsical gifts. Downstairs is a working glass studio where you can see artist Caryn Samuell working her magic with glass jewelry, recycled and fused glass window sculptures, and etched glass stemware. Her glass workshop also stocks an extensive inventory of glass and supplies for both the hobbyist and professional glass artist. Stopping here is a treat, with her pet chickens behind the barn and picnic tables in the yard.

Peter Coes' Gallery will be next, behind a white picket fence, .5 miles along route 6A. (Next page)

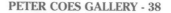

PETER COES GALLERY - 38
4405 Main Street, Cummaquid - Year Round
June-October, weekdays, 11am-6pm
weekends, 10am-6pm
November-May, weekends, 10am-5pm
weekdays by appointment or chance
508-362-2534 • www.petercoesgallery.com

In Peter Coes' intriguing converted barn studio, a visitor sees the artist at work, from inspiration to final painting or sculpture. Aside from his own art, a second room is filled with varied works from other top New England artists. In his recent work, Peter has turned his training in sculpture and talent for painting into the creation of miniature dollhouse-like buildings: architectural renderings in three dimensions of charming cape cottages and lighthouses, one seen here. The miniatures, like his paintings, seem tinged with a blue aura, a sense of nostalgia that mixes with the quiet details in the work. Peter loves to converse with visitors about art and the creative process.

As you continue east .7 miles, you'll enter Yarmouth Port. Right after Hallet's you'll see a red sign in the front yard of Fresh Paint Gallery.

FRESH PAINT GALLERY - 39
143 Route 6A, Yarmouth Port
March, Friday and Saturday, 11am-4pm
April and May, Thursday-Sunday, 11am-5pm
June-December 11am-5pm; Closed Tuesdays
508-375-9220 • 508-428-5478 (off-season appts. only)

Contemporary fine art by award-winning Cape Cod artists is on display in a warm, intimate setting at the Fresh Paint Gallery. A variety of media is represented: oils, watercolors, pastels, monotypes, and sculpture. Styles cover a wide range from representational to abstract. There are still lifes, landscapes and figures. Artists represented are Julie Blanchard, Robina Carter, Jim Campbell, Claire Marcus, Robert Mesrop, Ken Northup, Ann O'Connell, Lynne Schulte and Selma Alden whose painting of the gallery is shown here. The Greek Revival house, on the National Register of Historic Places, still has its original windows with hand-blown glass and wide pine floorboards.

*Travel through Yarmouth Port on Route 6A to the Yarmouth Port
Common, which is on the right side of the street. The Edward Gorey
House overlooks the Common on Strawberry Lane.*

EDWARD GOREY HOUSE - 40
8 Strawberry Lane, Yarmouth Port
April 15-late December
Admission: Adults $5, Seniors/Students $3,
Children (6-12) $2, Under 6 free
508-362-3909 • www.edwardgoreyhouse.org

The Edward Gorey House celebrates the life
and work of this acclaimed writer and artist.
Featuring exhibits of Gorey's professional work,
personal life and legacy of supporting animal
welfare causes, it gives the visitor a glimpse into the
mind and life of one of America's truly great creative
geniuses. Special exhibits include those of Academy Award-winning
animator and writer Derek Lamb, who brought life to Gorey's artwork
in the PBS "MYSTERY" series' opening and closing credits, and the
original set and costume designs for Gorey's "Dracula" the Tony
Award winning Broadway hit. Check the website for details on
exhibits and extended schedules.

*Traveling east on 6A, you'll see a sign for Kings Way on your left. Turn
into it, and go slightly more than a mile past the Village Green. Take the
third right after the Green, and pull into the driveway at the third house
on Pine Grove. Enter the studio along the right side of the house.*

SAILOR'S VALENTINE STUDIO - 41
8 Pine Grove, Yarmouth Port
June-September, Friday, Saturday, 11am-3pm or by appointment
508-362-8410 • www.sailorsvalentinestudio.com

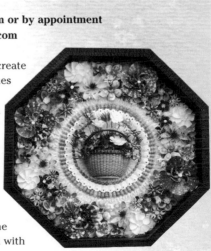

Artist Sandy Moran became inspired to create
sailor's valentines while walking on the beaches
of Cape Cod and Sanibel Island in Florida.
Nationally acclaimed, she has been described
as having the skills of a watchmaker in
crafting these intricate pieces. Besides
colorful shells from all over the world, she
places portraits, miniature Nantucket
baskets and even ivory scrimshaw in her
pieces. Although she has been known to
incorporate ideas from traditional work, her
designs are unique. With painstaking work, she
creates heirloom pieces of art that are graced with
the aura of a more romantic age.

SAILOR'S VALENTINES: In the 19th century, sailors stopping over on the island of Barbados would choose from a selection of elaborate and colorful shell collages made by islanders. The heart-shaped mementos became a popular present to bring to loved ones waiting at home. They became known as Sailor's Valentines, because it was long thought that sailors made them on board ship. Today, several artisans in the region specialize in Sailor's Valentines, keeping this historic art form alive.

Get back to Route 6A, turning left out the gate. As you pass Captain Frosty's Restaurant, you'll see South Yarmouth Road. Make a right onto it. Two world class bird carvers are close together. Go .3 miles and pay attention here, as there is no street sign. All this is on the left. Take the first left on Thoreau Drive, then left on Sou'West Drive, left on Walden Place. At the Corner of Sou'West and Walden place is #5 on the left.

FISHER BIRD CARVINGS - 42
5 Walden Place, Dennis
May-December, Monday & Wednesday 10am-4pm
Other times by appointment
508-385-2880 • www.fisherwildlife.com

Randy and Elaine are a husband/wife team of naturalists who bring skill and discipline to their craft. Both are avid bird watchers and devote as much time as possible to the study and photography of their subjects. They have banded

birds for US Fish & Wildlife at Manomet & Mass. Audubon and so have held almost every bird they carve, alive, in hand. Their love of nature can be seen through the array of carved birds that populate their studio. Carving full time professionally since 1978, their work is in private collections all over the world. Each piece is a one-of-a-kind, signed original. They have won awards at the World Championship in MD. professional class, and the Connecticut Wildfowl Competition.

Getting back to Thoreau Drive, turn left and almost immediately after a brown house on the left, there will be a dirt road at an angle. Go up this road to the fourth driveway on the left to see a decoy and bird carver and his wife, the Chair Ladi. The Harrington's mailbox is out front.

CAPE COD DECOY AND WILDLIFE ART AND THE CHAIR LADI - 43

38 Madison Road, Dennis - Year Round
Tuesday & Thursday, 10am-4pm
Weekends by appointment
508-385-9417

Tim Harrington, a decoy maker and bird carver, grew up in Harwich and has never lost his interest in wildlife on the Cape. He and his wife Mary Ellen, who restores antique chairs, share studio and gallery space in a section of their house. Tim's three-dimensional decoys and birds are considered world-class. His carved feathers actually look like real feathers. Besides carving decoys, he works on "flat Art," watercolor, Acrylic painting fish and birds on navigational charts. He also paints beach and wildlife scenes and sells the images as limited edition prints. Tim has returned to competition in World and National shows after long leaving that phase and has done well in the World competition and looks forward to doing three to four shows a year. Mary Ellen, called the Chair Ladi, does re-caning, seat weaving, and fiber rush work on antique chairs. She also weaves baskets, she has done this for refinishers and shops in several states.

Continue east on 6A. Right across from the Dennis Public Market, turn left onto New Boston Road. You'll be heading into residential sections of Dennis, staying left at the signs to the beach. Go .7 miles to where the road splits (Bristol) and stay left. Go .2 miles to Wind Shore Street. There is a green on your left. Stay on the near side of the green and the Bonnie Brewer's Studio is the second house on the left. (Next page)

BONNIE J. BREWER ARTIST STUDIO - 44
8 Wind Shore Street, Dennis - Year Round
June-September Saturday and Wednesday,
12-5pm Other times by appointment
508-385-2194

For Bonnie Brewer, being surrounded by the energy of the sea, plants and wildlife on Cape Cod moves her to observe the natural light effect on the landscape. Tucked into a residential neighborhood in Dennis, Bonnie's in-home studio abuts a conservation area. She is fascinated to find the extraordinary in an ordinary still life. Visitors enter the studio portion of the house around the back through sliding doors. The space is both work shop and gallery. Bonnie paints there and displays her paintings, prints, note cards and tiles, ranging from abstract to quasi-representational work, throughout the house. She offers art classes in her home studio year round on Mondays and Wednesdays.

Heading back along Beach Road to New Boston Road to Route 6A, turn left and head to Dennis Village. Here, you can walk to a number of galleries and the Cape Museum of Art. Check local papers or with the galleries themselves for their special art walks and stroll events throughout the year. Turn left onto Hope Lane and find a place to park in the complex on the right, or pull into the parking lot for the Winstanley Roark Fine Arts Gallery, which is on the northwest corner of 6A and Hope Lane.

CAPE COD CENTER FOR THE ARTS: Art lovers exploring Cape Cod tend to gravitate to the 26-acre campus in the center of Dennis Village on Route 6A that includes the Cape Playhouse, Cape Cinema, and Cape Cod Museum of Art. The Cape Playhouse, which began in 1927, is where stars like Bette Davis, Ginger Rogers and Humphrey Bogart strutted their stuff before catching their big breaks in Hollywood. The building is a former Unitarian Meetinghouse, and the original pews, now with cushions, still serve as the seats. The playhouse features a half-dozen plays throughout the summer, as well as children's theatre. For movie lovers, there is no better venue than the Cape Cinema. The crowning glory of the space is the large ceiling mural, designed by Rockwell Kent in 1935 when he was one of America's most controversial artists. The subject is a symbolistic vision of the heavens with pairs of embracing lovers floating through the sky.

WINSTANLEY-ROARK FINE ARTS - 45
744 Route 6A, Dennis, MA
July-August: Tuesday-Saturday 10am-5pm
September-December & April-June:
Tuesday-Sunday, 11am-4pm, closed holidays
January-March: by chance or appointment
508-385-4713 • www.masterfulart.com

Fine Arts photographer Anita Winstanley Roark and painter Robert Roark are the forces behind this gallery of Contemporary Realism and American Impressionism. Painting, photography, sculpture, stained glass and limited edition giclées by gallery artists are displayed in this charming old Cape Codder. The artists represented are museum-recognized and internationally renowned. You can visit Robert Roark and Anita Winstanley Roark in their studios, a unique opportunity to view works in progress and to discuss the creation of your own personalized landscape, still life or portrait commission. Private painting and photography classes are also offered by both Anita Winstanley Roark and Robert Roark.

Three studios are located in the same complex across the street: a Victorian-era house, opposite the church and the village green, all within walking distance from the museum. A fourth, Harvest Gallery and Wine Bar, is adjacent to the complex.

BAKSA STUDIO - 46
766 Route 6A, Dennis - Year Round
Memorial Day-Labor Day Monday-Saturday, 10am-5pm;
September-December Tuesday-Saturday, 10am-5pm;
January-May call for hours Closed major holidays
508-385-5733 • www.baksa.com

Set in a Victorian-era farmhouse, Baksa Studio is a working studio/gallery that features the fine gold and gemstone jewelry of Michael Baksa and the paintings of Teresa Baksa. Mike creates his jewelry at the shop using luminescent pearls, diamonds, and sapphires, among other gems, and he'll gladly explain to visitors the role that

the colors and shapes of gemstones play in the creation of each piece. Teresa's paintings, prints, and watercolors, many of which are landscapes, capture a distinct mood and moment, for example, a hawk in flight or shadows cast by a towering dune.

The next studio is in the same building as Baksa, but tucked around the back. Take a left out of Baksa Studio and go around the building, you'll see the beautiful sculptures of the next artist.

THE DECORATIVE PAINTER ART GALLERY - 47
766 Main Street, Dennis - Year Round
June-September, Friday and Saturday, 10am-5pm
Sunday by appointment
Year Round Saturdays, 10am-5pm
508-385-2026

As visitors enter the workshop and gallery of decorative painter Michael Giaquinto, they are greeted by his signature birdhouses and painted furniture. Michael, who was declared one of Early American Life Magazine's top 200 craftsmen in the country, is a specialist at painting techniques. He uses all the skills of the muralist to create painted furniture, decorative and personalized objects. For example, he mixes a powdered pigment with cider vinegar, which he calls poor man's varnish, to give his new boxes the look of antiques. He also makes sailor's valentines and mirrors within painted frames.

Exit Michael's studio in the back, and you will see Mill Stone Pottery with its bright yellow exterior.

MILL STONE POTTERY - 48
766 Route 6A, Dennis - Year Round
June-December, Monday-Saturday, 10:30am-5pm
January-May, Wednesday-Saturday, 10:30am-5pm
508-385-4214 • www.millstonepottery.com

Potter Gail Turner produces both functional and decorative clay work. Each piece is wheel thrown and or hand built using slab, extruded or pressed techniques. Both production and one of a kind pieces are individually made by hand. Gail can usually be found at her wheel throwing pots, trimming and assembling thrown pieces from the previous day, or hand building one of her large lasagna pans. Her work reflects her love of pattern and texture and her background in design. Of particular interest to Gail is the batik process as it is used on cloth and Ukrainian eggs. From this interest has evolved her wax resist glaze techniques, which are complemented by her shino, Temoku, and ash glazes.

Harvest Gallery and Wine Bar is located slightly behind Mill Stone. Turn left out of Mill Stone's door and you'll see it on your left.

HARVEST GALLERY AND WINE BAR - 49
776 Main Street, Dennis
January 1-April 1 call for hours or appointment
April-December Wednesdays 10am-4pm,
Thursdays-Sundays 10am-11pm (wine bar weekends)
508-385-2444 • www.harvestgallerywinebar.com

Harvest Gallery Wine Bar entertains all of the senses. Owner/Artist Michael Pearson creates an artistic and cultural atmosphere like no other-an intimate, diverse gallery featuring Cape Cod Contemporary Art representing over 30 artists creating paintings, collages, sculptures, assemblages, photography, glass and more. All this accompanied by a Wine Bar featuring over 20 wines by the glass, beer, a full menu with seasonal specials, desserts and live music.

You can enter the Cape Cod Museum of Art parking area off Hope Lane, just past two white mail boxes on the right, or you can walk to the Museum from the galleries on 6A. (Next page)

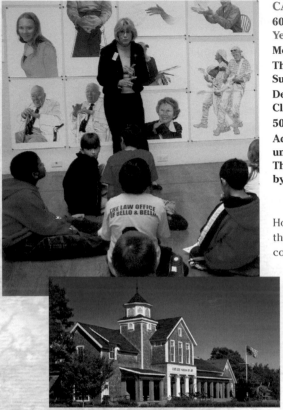

CAPE COD MUSEUM OF ART - 50
60 Hope Lane, Dennis
Year Round
Monday-Saturday, 10am-5pm
Thursday till 8pm,
Sunday 12-5pm
December-March,
Closed Monday-Wednesday
508-385-4477 • www.ccmoa.org
Admission is $8. Children 18 and
under are admitted free.
Thursday admission is
by donation.

In 1981 sculptors Harry Holl and Roy Freed founded the museum to collect, conserve, study, interpret and exhibit works by outstanding artists associated with Cape Cod, the Islands, and Southeastern Massachusetts, from the 19th century to the present.

The collection includes contemporary and historically significant art from this region. The museum is located on the campus of the Cape Cod Center for the Arts and offers 32 exhibitions a year in its seven galleries. The Weny Education Center and Harry Holl Sculpture and Clay Studio offer year-round classes and workshops for adults and children. The museum also has regular docent tours, gallery talks and special events. There is a sculpture garden, screening room, art reference library and a small museum shop.

As you leave the museum go out towards the Cape Cinema and Dennis Playhouse Turn left onto Route 6A past glimpses of Scargo Lake. You'll see Dr. Lord's Road on the right, at the curve. Turn in. The driveway leading to Scargo Gallery is on the left.

SCARGO POTTERY & ART GALLERY - 51
30 Dr. Lord's Road S, Dennis - Year Round
10am-5pm, (6pm in the summer), 7 days a week
508-385-3894 • www.scargopottery.com

This magical art spot, set in a wooded area off of Route 6A, is one of the Cape's "don't-miss" experiences. Oversized vases, tile installations, sculptures, bird castles, and all manner of pots large and small decorate the yard and outdoor gallery where Harry Holl, the family patriarch, opened Scargo Pottery in the summer of 1952. The gallery and open studio have been a work in progress ever since, as members of the extended Holl family have joined the family business. Among Harry Holl's numerous apprentices over the years are his four daughters, Tina, Kim, Mary, and Sarah, each with a style all their own. The potters at Scargo mix their own clays and glazes from raw materials, allowing for constant experimentation and unexpected effects

Continue on Route 6A .7 miles to Ross Coppelman on the right, before the intersection of Route 134.

ROSS COPPELMAN GOLDSMITH, INC. - 52
1439 Route 6A, East Dennis - Year Round
May-December, Monday-Saturday, 10am-5pm,
January-April, Tuesday-Saturday, 10am-5pm
508-385-7900 • www.rosscoppelman.com

Goldsmith Ross Coppelman has designed custom jewelry for more than 30 years. With an intuitive eye for detail, color and aesthetics, his name has become synonymous with top-quality craftsmanship and design. Visitors admire elaborate gardens on the way into the Coppelman showroom on Route 6A. Inside, the jewelry—pins, necklaces, earrings, rings and bracelets—is displayed in glass cases. This is jewelry to touch the senses: pendants featuring sapphires arranged as constellations, gold bracelets containing shapes inspired by ancient Egypt, and rings decorated with a diamond sunburst. Rings from his new Ocean Wave Series are pictured here. Custom jewelry is a specialty.

The sea that surrounds this proud peninsula has many moods. On calm days, it is gentle and welcoming, and on stormy days it is forbidding and dangerous. Over the hundreds of years since Europeans first settled on these shores, the sea and the natural and man-made harbors have provided a sometimes hazardous but profitable livelihood for generations of Cape Codders. These harbors are part of our heritage, and in addition to

meeting artists in their studios and workshops, visitors can also stop at several picturesque harbors on this trail. The Ports Trail follows Cape Cod's southern coastline through the small towns and villages of Yarmouth, Dennis, Harwich and Chatham.

Linking these charming communities are the Bass River, Harwich Port's Allen Harbor, Wychmere Harbor, and Saquatucket Harbor, and Chatham's Stage Harbor. Each harbor has its own story. For example, Wychmere Harbor used to be Salt Water Pond, and in the 1880s, a half-mile horse racing track was built around it. Each artist on this trail also has a story. There is the woman who travels the world collecting gems for handmade jewelry and the region's only pewter crafter. Followers of this trail will find handmade glass marbles and elegant

Trail 3
String of Ports Trail

Yarmouth to Chatham

ceramic teapots, unique sculptures, and beautiful jewelry.

This area offers much to see in addition to the artists on this trail. Harwich is where commercial cranberry growing first got its start.

The Brooks Academy Museum in Harwich Port has many mementos of this important Cape Cod industry. Chatham, tucked into the elbow of the Cape, is a picturesque New England village that also has a sizable fishing fleet. People travel from miles around to attend the summer bandstand concerts and to shop on Chatham's bustling Main Street.

How To Use This Trail

The Ports Trail is designed for exploring the south side of the Cape, bordering Nantucket Sound and the Atlantic. You start around Bass River and can make a good morning or afternoon trip visiting the artists up to Dennisport. The second grouping is around Harwich and Harwich Port, with artists along Rte 28 that have unique offerings and a few in residential areas off the beaten path, but worth finding. Most of the artists on the trail are clustered around Chatham, which lends itself to multiple visits. Along with walking on Chatham's Main Street and finding galleries and studios among the attractive shops, the outlying studios are perfect forays to various vistas, like Harding Beach, Chatham Light, and also views of Pleasant Bay heading north from Chatham towards Orleans. The trail goes west to east.

String of Ports Trail

This trail begins in Yarmouth, at the intersection of Route 28 and Station Avenue. Coming from the Mid-Cape Highway, take Exit 8 and head south about 2 miles on Station Ave. Cross Route 28 onto Old Main and go one block further. The Center is just west of the Bass River on your left.

CULTURAL CENTER OF CAPE COD - 53
307 Old Main Street, South Yarmouth
Year Round, **Wednesday-Sunday**
11am-5pm, With evening events
508-394-7100 • www.cultural-center.org

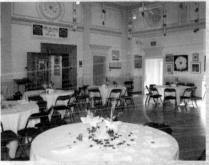

With a motto All the Arts for All of Us, the Cultural Center of Cape Cod is a focal point for the community and visitors interested in culture and the arts by offering instruction, entertainment and exhibition. Four changing galleries focus on local artists and a fifth features a variety of high quality but affordable work by Cape artisans: pottery, glass art, books, music, textiles, jewelry, baskets, note cards, tiles, and more. The Center also offers many forms of entertainment, including concerts, dances, lectures, readings, plays, films, and free art receptions. Classes in everything from music and rug braiding to painting and fly tying, plus summer art camps for kids, are available for many age groups. Located in the beautifully restored Bass River Savings Bank, the building itself is a work of art. Everyone is invited to meet the artists at their free Opening Receptions, generally on Fridays from 5-7pm. Go to their website for extensive special events listings and downloadable copies of the Center's most recent newsletter.

Turn right out of the driveway and left onto Route 28, passing over the Bass River. In 1.3 miles you'll see a grey full Cape with pink awnings on your left. Parking for Etta's Jewelry is right past her shop. (Next page)

JEWELRY BY ETTA - 54

530 Route 28, West Dennis - Year Round
January-March, Wednesday-Saturday 10am-5pm
April-June Tuesday-Saturday 10am-5pm
July-December, Monday-Saturday 10am-5pm,
Sunday 11am-4pm
508-394-8964 www.jewelrybyetta.com

Distinctive jewelry awaits you when you visit Etta in her 200 year old studio/shop. Creating pieces of exclusive wearable art jewelry set with natural gemstones in 14 karat gold and sterling silver has been her life-long passion. Etta has an extensive selection of Australian Opal jewelry encompassing a wide array of colors. You will find amazing gemstones from Alexandrite to Zebra Agate, every one uniquely handcrafted by Etta into a one-of-a-kind jewelry treasure. Etta and her expert staff can help you make your selection from her impressive display of jewelry; or Etta will work with you to design and create a custom piece of wearable art just for you or your special someone.

Make left out of parking lot, continuing east on 28 to the light at the intersection of Route 134. Turn left onto Route 134. then right (just over 1 mile) on Upper County Road. shortly after Clancy's Restaurant, look for a Glass Blowing sign on the left (across from Hart Farm).

FRITZ GLASS - 55

36 Upper County Road, Dennisport - Year Round
Daily, 11am-5pm or by appointment
508-394-0441 • www.fritzglass.com

Fritz Glass is very much a family affair with glass blower Fritz Lauenstein and his wife, June Raymond, a potter who is running this studio and gallery. Glass marbles are a specialty here. Since 1986, when Fritz first began making marbles, he has become one of the leading marble makers in the country. His marbles can be found in numerous collections as well as galleries across the United States. Fritz's colorful blown glass pieces and June's sculptures are displayed throughout the large open gallery. The glass-blowing studio is visible as part of the gallery.

Turning left out of the shop, continue to Route 28 and travel east for 1.5 miles.
Turn left onto Route 124/39 (Sisson Rd). Go .25 mile. After you see Circadia Inn
& Tavern, take your next right on to Gilbert Lane, then first right on Old Tavern
Lane. Heather Blume's Studio is #19 on the right, turn in at the second driveway
for the studio/barn.

HEATHER BLUME STUDIO & GALLERY - 56
19 Old Tavern Lane, Harwich Port - Year Round
Memorial Day thru Columbus Day Weekends
Saturday 10am-4pm, Sunday 12pm-5pm
Other times by appointment 508-430-1945
508-292-1113 • www.heatherblume.com

Heather Blume creates original sculpture, paintings and drawings concerned with the human condition. Full of movement and color, her sculptures have innate energy. Her series, Fortunata's Circus, features a gypsy-like troupe of performers: acrobats, a trapeze artist, and even a high wire cyclist, whose characteristics reveal metaphors for human fate. The Aquatic Series speaks to myth and sea lore with hybrid creations that are part-person, part sea creature. Heather's artistic ability runs in the family. Her father made reproductions of Early American furniture and her mother was a painter.

Retrace your steps to 28 and turn left and travel a little over 2 miles,
through the village of Harwich Port to the next artist, the only Pewter
Crafter in the region. Just after L'Alouette Restaurant on the right, you'll
see a sign for Pewter Crafter Cape Cod.

PEWTER CRAFTER CAPE COD - 57
791 Route 28, Harwich Port - Year Round
May-October, Saturday and Sunday, 12pm-4pm
Other times by chance or appointment
Closed Memorial Day, July 4th, and Labor Day
508-432-5858 • www.pewtercraftercapecod.com

Ron Kusins operates the only pewter shop on Cape Cod. The contemporary and traditional designs are all handmade in his studio in the finest lead-free pewter alloy. The designs of the traditional pieces come from the simple, clean lines of the Colonial period. Ron's contemporary pieces reflect a commitment to the elements of classical form, well-defined lines and elegant curves. His inspirations come from all around him. He'll point out the designs that come from the ferns growing across the street from the shop and the shells he collects on the beach. The scallop shell provides one of his signature elements.

Leaving his gallery, go only .2 miles east and pull into 820 Main on the other side of the street, to visit the next two galleries, 820 Main and Hopkins, in the same complex of buildings.

820 MAIN GALLERY - 58
820 Main Street, Harwich Port - Year Round
Memorial Day weekend through Columbus Day Monday-Saturday 10am-5pm, Sunday 1pm-5pm Mid November to Christmas, Friday and Saturday, 10am-4pm, Sunday 1pm - 4pm; January to May Saturday 10am-4pm • 508-430-7622

This colorful gallery displays a collection of works from some of the finest Cape Cod painters, including well-established Boston painters who have retired to our area. There are oils, acrylics, watercolors, and mixed media paintings in three large rooms, showcasing regional landscapes, still lifes and portraits. A large lower gallery shows limited edition prints, photographs and gift items. Visitors will always find one of the artists tending the gallery, often times painting. The artists are Vivien Oswell, Milton Welt, Larry Folding, William Maloney, Joyce Hawk, E. R. Lilley and D. Julian Spillane.

Behind 820 Main you'll see a second studio, where watercolorist Patricia Hopkins paints and shows her work.

THE HOPKINS GALLERY - 58
820 Route 28, Harwich Port - Year Round
Memorial Day weekend through Columbus Day Friday, Saturday and Monday 10am-5pm, Sunday 1pm-5pm; Mid November to Christmas, Friday and Saturday, 10am-4pm; Sunday 1pm - 4pm January to May Saturday 10am-4pm • 774-209-9473

Patricia Hopkins' light airy studio gallery next to 820 Main has original watercolors, giclee prints, and note cards that portray the beauty and peace that the artist sees in nature. She was one of the original members of "21 in Truro." Focusing on composition, realistic drawing and carefully mixed colors, Patricia creates unique watercolor paintings that draw the viewer into the scene. Like many of the region's artists, Patricia appreciates the special light that blankets the Cape, and she uses this with great skill in a wide variety of subjects, including realistic water textures, nautical and beach scenes and florals.

*Turning left out of the driveway and continuing
towards Chatham, you'll travel a little over a mile.
Just before the junction of Rte 28 and Rte 137, turn
right into Juniper Lane. Across from the South
Chatham Post Office is the Chatham Media Center.*

CHATHAM MEDIA CENTER/ CHRISTOPHER SEUFERT GALLERY - 59

2469 Main Street, S. Chatham - Year Round
Tuesday-Saturday 10am-4pm
508-430-2866 • www.capecodphoto.net

 The author of three published
Cape Cod photography books,
Christopher Seufert's photos have a
spontaneous quality that immerses you
in the scene. An engaging Chatham
native, his vintage camera collection
leads to conversations about how he
uses them to create a unique sense of
place. Seufert's rough and ready
approach communicates the locations
on their own terms, and is beautifully
presented in his large format framed Cape Cod,
aerial, and Chatham prints. He also has a renowned
audio series of Cape Cod natural environments
available in his Cape Cod Soundscapes CD series,
which makes a great accompaniment for the rest of
your travels on the trail. Also in the media center
are don't-miss stops with jeweler Amy Gregorio and
the Caped Cod vinyl and CD store.

*Here there is a detour to two wonderful painters, one
open Thursday and Friday and the other Wednesday
and Thursday. Both are worth visiting on those days.
On other days, continue straight along Route 28 to
Barnhill Pottery.*

*Travelling on a Thursday, you can see them both by
going to Frances McLaughlin's studio first. To get
here, turn left onto Route 137. Go straight 1.3 miles to
a blinking four way stop. Continue straight through
two more traffic lights. Make the third right after the
movie theater onto Sherwood Road. Frances
McLaughlin's beige house is the seventh house down
on the right as the road curves. Her studio is behind
her house. On Wednesdays, you will backtrack to
Route 28 to continue the trails. (Next page)*

FRANCES MCLAUGHLIN STUDIO - 60
34 Sherwood Road, East Harwich
June 1-September, Wednesday-Thursday, 10am-2pm
508-430-8305 • www.francesmclaughlin.com

After a career as a graphic artist for a local newspaper, Frances McLaughlin began to focus on her painting. She works in oils and pastels, and paints with emotion. Her work has become more impressionistic, as she deals with a gradual loss of sight, but her style and the feelings that comes through the work keeps her paintings in high demand. An award winning painter, she recently had an exhibit at the Cape Cod Museum of Art. Her studio is located in a separate building at the rear of her house where her pastels and easels are always at ready. Frances continues to inspire others, maintaining her upbeat spirit as she teaches art to the visually impaired.

If it's a Thursday, coming from the studio above, get back onto Route 137 towards Chatham (turning left), returning to the blinking light, Queen Anne Road, and make a left. (On Friday, the directions will be from Route 28 to the blinking light taking a right.) Take an immediate left onto Church Street, following it to the four way stop, intersecting Bay Road. Turn — onto Bay, and Nest Studio will be on your —.

NEST STUDIO - 61
131 Bay Road, East Harwich - Year Round
June-September, Thursdays and Fridays, 12pm-6pm
Other times by appointment
508-274-9037 • www.greentwig.com

The studio of artist Jennifer Morgan's shows her vivid graphic-style oil paintings in a newly constructed 'green' live/work space. The lower level of the eco-friendly passive-solar structure houses the studio; which overlooks giant spruce, hemlock and a grassy meadow abutting acres of conservation land. Jennifer's work has been shown nationally from Santa Monica to New York and is in the collections of some of the major literary figures of our time as well as luxury resort destinations including the Chatham Bars Inn. Jennifer's small 'block' paintings have been featured in national magazine publications spanning a period of the last ten years.

From the junction of Route 28 and Rte 137, you'll travel 1.8 miles to Barnhill Road, which is also the road to Harding Beach and right past the Shop Ahoy Plaza, on the right. Turn right almost immediately into the seashell driveway of BarnHill Pottery, right after hedges.

BARNHILL POTTERY - 62
46 Barnhill Road, West Chatham - Year Round
Daily, 10am-5pm; Sunday 12-5pm
508 945-1027 • www.Barnhillpottery.com

Susan Dimm Williams' gallery is set in a post and beam barn she built next to her home. The pottery is displayed in an array of old cranberry boxes and on top of nail kegs, in lobster traps, and fish boxes. She creates about 12 new items each year based on the functional needs of everyday life, some requested by family and friends, or created while working in the kitchen. Susan's large studio space is right behind the gallery, so you can see her throwing pots as you walk in. Ask to see her handout on the cost of throwing a mug.

Getting back to Route 28, turn right and head towards downtown Chatham, travelling about 1.4 miles. Right before the light, you'll see Munson Square and the Munson Gallery on the left, one of the oldest art galleries in the country.

THE MUNSON GALLERY - 63
888 Main Street, Chatham
May 1-May 25, Friday & Saturday, 11am-4pm
May 26 - September 15, Daily, 10am-5pm
September 15 - October 15, Wednesday - Saturday
11am-4pm; October 16 - November 30, Friday &
Saturday, 11am-4pm, Otherwise by appointment
508-945-2888 • www.munsongallery.net

The Munson Gallery is a Chatham landmark. One of America's oldest art galleries, the business was originally established in Connecticut in 1860. A branch has been in Chatham since 1955. The gallery is owned and operated by Sally Munson, the great granddaughter of the gallery's founder. The Munson Gallery features the work of more than 30 well-known artists from the region. Paintings range from realistic to abstract, but the majority are inspired by Cape Cod's unique landscape.

*The easiest way to the next stop is to go through the
back of Munson Square and then turn left onto
Crowell Road. The Creative Arts Center is on the
right. Parking is available in the rear.*

CREATIVE ARTS CENTER - 64
**154 Crowell Road Chatham - Year Round
June-September 30th, Monday-Friday,
9am-4pm, Saturday 10am-4pm,
October-May 31st, Monday -Friday, 9am-4pm
508-945-3583 • www.capecodcreativearts.org**

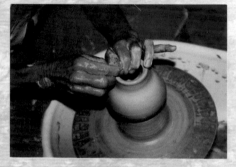

The non-profit Creative Arts Center offers
year-round classes and workshops by
nationally recognized artists from Cape
Cod and across the country. The Center's
teaching facility includes two painting
studios, a pottery/sculpture
studio, darkroom, jewelry studio,
children's classroom and library. Each
year more than 80 classes are offered in
oil painting, pastel painting, watercolor,
drawing, pottery, sculpture, jewelry
design, photography, and printmaking.
There are also lectures in art history
and art appreciation, as well as painting
demonstrations. Exhibitions are on display in the
Joan P. Somy Gallery and the Edward A. Bigelow
Gallery including members' shows, open, juried,
and themed shows.

*Return to Route 28, turning left and continuing into
Chatham. Before you get to downtown and only .2
miles from Crowell Road will be the Chatham Glass
company on your left. It's a little set back from the
road. Look for the high Chatham Art Sign, and you'll
see all the beautifully colored glass in the windows.*

LIGHTHOUSES: The shifting shoals off the Cape's coast gave the area off Cape Cod the name,
"the graveyard of the Atlantic." By the late 18th century, Congress agreed to build the first
lighthouse on Cape Cod. Highland Light, also known as Cape Cod Light, still stands on a Truro
bluff, though it has been rebuilt over the years. Chatham Light, which is located next to the Chatham
Coast Guard Station, was the second lighthouse built on Cape Cod. There are several interesting
lighthouses to visit on the islands of Nantucket and Martha's Vineyard. Nantucket has Brant Point
Light, a small lighthouse that overlooks the harbor and is walking distance from town, and Sankaty
Head Light, on the east end of the island, which has a bold red stripe. On Martha's Vineyard, the
most famous lighthouse may be Gay Head Light, which sits out on the red clay cliffs of Aquinnah.
There is also Edgartown Light, located on its own little spit, a short walk from the center of
Edgartown. Lighthouses and other maritime sites can be visited during Maritime Days each May

CHATHAM GLASS COMPANY - 65

758 Main Street, Chatham - Year Round
June, Friday-Saturday, 10am-5pm
Daily July and August 10am-5pm
September, Thursday-Saturday10am-5pm
October to May call for hours
508-945-5547 • www.chathamglass.com

Bold, vibrant, and unusual uses of color are the hallmarks of the art glass produced by Jim Holmes, who uses traditional glass-blowing methods to create unique and colorful pieces of art. Visitors to the gallery can watch the glass artist at work. There are jewel bud vases, vases, bowls, platters, candlesticks and other one-of-a-kind pieces. Among Jim's eye-catching patterns is an exciting swirl featured on bowls and plates. He also makes bull's-eye glass, hand-blown and hand-cut, to be used in people's homes to re-create a Colonial look.

Pull out of driveway and turn left heading into Chatham. Go halfway around the rotary to downtown, and find a place to park. If you're lucky, park in the Chatham Town Hall parking lot, or near Emack and Bolios (on the right side of the street) because at the end of the path, next to The Children's Shop building, is the Chatham Village Gallery. And, you can access the rest of the downtown galleries easily by foot.

CHATHAM VILLAGE GALLERY - 66

37 Kent Place, Chatham, Memorial Day - Columbus Day open daily 11am-5pm, Spring & Autumn open Fri, Sat Sun 11am-5pm, Open by chance or appointment January 15-April 15th, 508-945-0070

An intimate gallery located slightly off Main Street in the heart of historic downtown Chatham, Chatham Village Gallery offers a variety of original fine art by award winning artists from Cape Cod and beyond. The works include oil, acrylic, and watercolor paintings in a wide range of subjects and styles from traditional to contemporary, sure to please art lovers. It also offers a selection of fine art note cards and reproductions. Complimenting the fine art is a selection of original jewelry in sterling silver and gold created by long time Cape Cod Jeweler Teresa Ellis Cetto. The gallery represents former juried artist members of "The Artists Gallery:" Bruce W. Cook, Frances Duval, Robert McCulloch, and June Yeomans, as well as Richard Muccini, Russell Vujs,(SAMA) Irma Cerese and Kevin Doyle.

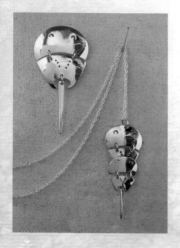

IMAGININGS IN GOLD & SILVER - 66

Within the Chatham Village Gallery
37 Kent Place, Chatham, Memorial Day - Columbus
Day open daily 11am-5pm, Spring & Autumn open
Fri, Sat Sun 11am-5pm, Open by chance or
appointment January 15-April 15th
508-945-0070 • 508-760-6927 (home studio)
www.teresacetto.com

Visit Teresa Ellis Cetto at The Chatham Village
Gallery. A member of the Society of Cape Cod
Craftsmen and the Artisans Guild of Cape Cod,
Teresa can often be found at their regularly
scheduled annual fairs. Teresa designs and crafts
one-of-a-kind bracelets, brooches, earrings, and
necklaces, including her most unique and
copyrighted horseshoe crab design. Her work is
inspired by Cape Cod, the sea, the beach, the light.
Whether it's a bracelet created out of amber, green,
or lavender sea glass, attached with sterling silver
mermaids, or a necklace featuring a stately heron
of sterling silver, these are unique pieces.

Returning to Main Street, cross the street to the
Chatham Art Gallery, in a brick building just past
Chatham Bars Avenue.

THE CHATHAM ART GALLERY - 67

464 Main Street, Chatham
Daily, April 15 - October 31, 10am-5pm,
July & August, 10am-8pm, 'til New Years
weekends only. Open Christmas week full time
508-945-4699

Owned and operated by artists, Chatham Art
Gallery displays the work of seven diverse locals.
Among the art on view are oils and watercolors by
Brewster resident Debra Ruddeforth and fine art
photographs, both black and white and color, by
her husband, Tom Ruddeforth. Painters LaVerne
Christopher, Maureen Leavenworth, Richard
Muccini, Susan Fehlinger, and Heidi Gallo are all
featured at this cooperative, working in oils,
watercolors, pastels, and acrylics. Other media
represented at the gallery include limited edition
prints and Gayle Condit's Sailor's Valentines. The
gallery, established in 1988, is a perfect stop near
the center of the village.

A few doors away on the same side of the street is Struna Galleries

STRUNA GALLERIES - CHATHAM - 68

458 Main Street, Chatham - Year Round
May-December: Daily 11am-5pm,
Closed Wednesday
July & August: Daily 11am-8pm Sunday 12-5pm
January - April: Call for hours
508-945-5713 • www.strunagalleries.com

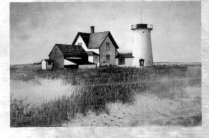

Struna Galleries, established in 1998 is owned and operated by Heather Struna. She is proud to represent her father, artist Timothy Jon Struna. This charming gallery is nestled in the heart of downtown Chatham Its open and airy interior reflects the Cape's best qualities as seen in the artist's work. The gallery exclusively features his acrylic and watercolor paintings, limited edition giclee reproductions and original copperplate engravings. Heather is always available to discuss the process and techniques of her father's artwork.

You can now get back in your car for the next gallery, because they have off street parking, or continue on foot across the street and look for the sign for Odell Studios/Gallery. But don't miss going to the east end of Main Street, to see the unique mix of work by the Odells, highly respected Chatham artists.

ODELL STUDIOS/GALLERY - 69

423 Main Street, - Year Round
Monday - Saturday, 10am - 6pm
508-945-3239 • www.odellarts.com

Metal artist Tom Odell and painter Carol Odell have a unique property combining gallery and studios with their home and gardens on Main Street. The Greek Revival house contains the welcoming gallery, some studio space and private living area. Larger work areas for sculpture and painting are in a separate studio building. Carol's non-objective oil and wax paintings and monotypes are composed with expressive colors and shapes. Tom's metal artworks include jewelry, vessels and sculpture. His use of a variety of metals and finishes creates a palette of rich warm colors to complement his refined sculptural forms.

THE RUBY RED CRANBERRY ON CAPE COD

When it comes to industry on Cape Cod, perhaps no business is more closely associated with the land than cranberry farming. In fact it was a Cape Cod sea captain, Henry Hall, who first successfully cultivated cranberries in Dennis in 1816.

Beginning in the years after the Civil War, immigrants from the Cape Verde Islands came to the Cape to work on the bogs. Generations later, the descendents of those workers are still very much a part of the fabric of communities on the Cape.

One Cape Cod artist, Kathleen Jones of Earth n Fir pottery tells the story of her grandmother, Edith Terry, who picked cranberries every year to make money to buy a new red wool coat. The pottery's cranberry design is in honor of her.

For those who want to witness a cranberry bog being harvested, there is the Falmouth Cranberry Bog Festival in October at the town-owned John Parker Road bogs, and you can tour cranberry bogs in Harwich through a working farm. Check with the Cape Cod Chamber of Commerce for more information.

In Harwich, the Brooks Academy Museum at 88 Parallel Road, Harwich has a permanent collection devoted to the history of the cranberry industry on Cape Cod, and the museum at the National Seashore also has displays.

Nantucket also has cranberry bogs. In fact, before 1959, the Milestone Cranberry Bog, at 234 acres, was once the largest contiguous natural bog in the world. The Nantucket Conservation Foundation holds a Cranberry Festival every year in October. Check out their website, nantucketconservation.org for dates and details.

On Martha's Vineyard, there are hundreds of acres of wild and cultivated bogs but most are not visible from public roads. An exception is Cranberry Acres, which is visible from Lambert's Cove Road in Vineyard Haven. The half-acre restored bog is managed by the Vineyard Open Land Foundation and is farmed organically.

Artists have long used cranberry bogs as inspiration, particularly in the fall when the bogs are flooded and filled with the vibrant ruby red bobbing fruits.

The cranberry industry even provides a historic home for one local artist: Timothy Jon Struna. Struna Galleries is housed in an 1880s carriage house in Brewster where cranberries were once processed.

*T*hey say 99 sea captains once called Brewster home. The small town on Cape Cod where this trail begins once had more captains than any other town in America. That was back in the 18th and 19th centuries when the profession meant sailing to the far corners of the world. What's left of this legacy are magnificent captains houses that line the Old King's Highway (Route 6A), the winding road that used to serve as a stagecoach route.

Follow this route to explore a part of Cape Cod that still has vestiges of Colonial days, as well as a range of talented artisans. Spend an afternoon in the shadow of the 1795 Higgins Farm Windmill at Drummer Boy Park. You'll find all the news you need to know on the steps of the Brewster General Store. And you can find tranquility around sunset at Paine's Creek, where at low tide the "Brewster flats" stretch for miles.

Within Nickerson State Park and the Punkhorn Parklands, both accessed from Route 6A, are trails crisscrossing almost 3,000 acres of conservation land. On these wilderness paths, stumbling upon a delicate pink lady's slipper, a rare orchid, is a transforming experience.

The Sea Captains Trail passes through Orleans, a lively town that is the home of many fine galleries and artisans. Artists here also look to nature for inspiration, for in Orleans begins what author Henry Beston called "The Great Beach." Forty miles of coastline is preserved forever as the Cape Cod National Seashore. The Seashore begins at Nauset Beach in Orleans, which extends as an

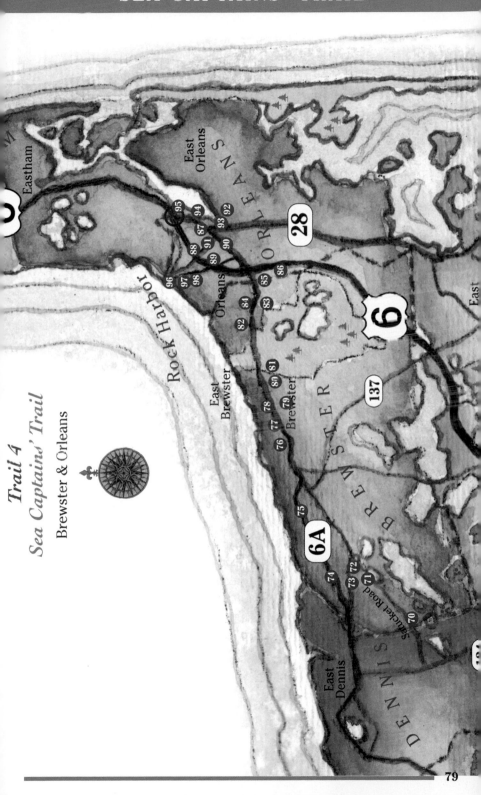

Trail 4
Sea Captains' Trail
Brewster & Orleans

undeveloped barrier beach south all the way into Chatham. It is this landscape of white dunes edged by the Atlantic Ocean, a never-ending horizon and the miles of intricate estuaries nearby that help define Orleans.

How To Use This Trail

Exploring this portion of Route 6A, the Old King's Highway, in Brewster and Orleans could easily take an entire week. Those who like to walk along the coast will want to stop at any one of the northside beaches to wander the flats at low tide when the russet sand reveals its stash of sea creatures and shells. Or, sit by Rock Harbor in Orleans when the fishing boats are coming in with their catches.

If you don't have the luxury of a full week, there are several ways to shape a shorter experience. Orleans, including a stroll through galleries in the village center

and a visit to Rock Harbor, makes an ideal half-day or one-day mini tour. A half-day in Brewster could include a stop at the General Store and a visit to a cluster of artists located along 6A. You can start the trail from the mid-Cape at Routes 134, 137 or 124. Be prepared for friendly artists and interesting conversations. Allow time to admire beautiful gardens. You are visiting one of the most concentrated areas of artists' studio/residences in the region. They love to have visitors stop by, so they can share their love of what they do.

Sea Captains' Trail

This trail begins at Rte 134. If coming from the Mid Cape highway (Rte 6), get off at exit 9B. Turn right on Setucket Rd. Just past first stop sign (junction of Airline, Setucket and Slough) turn right onto Slough Rd. Or, from 6A, go up Airline Rd which turns into Slough. The studio, a welcoming place for the contemporary art collector, is first driveway on left.

THE STUDIO ON SLOUGH ROAD - 70
75 Slough Road, Brewster
May-October, 10am-4pm daily
Saturday Evening Receptions
Winter/Anytime by appointment.
508-367-5749 • www.studioonsloughroad.com

Artist Kathleen Sidwell has created a wonderful artistic oasis at the end of her driveway. The Studio features her striking and emotional work in an abstract and contemporary style of paintings, prints, and mixed media. With her Studio Director, Laurel Labdon, they also host regular openings and receptions featuring artists, sculptors, writers and small performance groups on many Saturday evenings Mid June through Columbus Day. They welcome you to come by, preview the shows, enjoy the art collection and art library, and immerse yourself in art and culture.

Leaving the studio, go back to Setucket Road/Satucket Road, turn right and continue east approximately 1.8 miles, and on your left you'll see a sign for the Underground Art Gallery, one of the Cape's most unique galleries. *(Next page)*

STONY BROOK GRIST MILL: You can get to this picturesque site from the intersection of Satucket and Stony Brook Road. Visit Stony Brook Grist Mill and Museum open and grinding corn Saturdays and Sundays, June through August 10am to 2pm. The mill used to be in the center of a small manufacturing community founded after the Revolutionary War. What's left is this corn mill set beside bucolic Mill Pond. There's a small history museum upstairs. The herring run is active mid-April to early May when the herring climb the fish ladders to return to Mill Pond to lay their eggs.

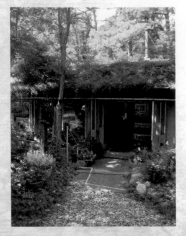

UNDERGROUND ART GALLERY - 71
673 Satucket Road Brewster - Year Round
Wednesday-Saturday 12-5pm
Call first in January, February and March
508-896-3757 • www.karennorthwells.com

Part fine art gallery, part architectural experiment, part environmental statement, the Underground Art Gallery is the work space of artist Karen North Wells and her husband architect Malcolm Wells. The gallery, designed by Malcolm, is actually covered with earth, with wildflowers growing on the roof and ten tree trunks serving as support columns. Karen's evocative paintings, including watercolors, oils, and acrylics, are mainly of sites nearby, like Paine's Creek, where she captures the graceful serene creek crossing through an autumn landscape. There are also cards, prints, books and tiles for sale.

Turning left out of the driveway, continue east on Satucket and almost immediately on your left will be AP Newcomb Road. Take that .5 miles, and turn left onto Stony Brook Road for a short detour to the only marquetry artist on the trails and one of the few weavers on the Cape. Brennan's Star Pottery and Marquetry gallery will be on the right, just past the church. You'll see their sign. The gallery is located around the back of the house.

BRENNAN MARQUETRY AND STAR POTTERY - 7
451 Stony Brook Road, Brewster
June-December; Thursday-Saturday, 12pm-4pm;
Other times by appointment or by chance
508-385-2970

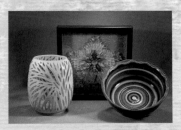

Tobey Hirsch Brennan works primarily in stoneware making functional pieces like bowls, vases, casseroles, colanders, and luminares. Some pieces are decorated by pierced work, like spheres for flower arranging. Glazes range from creamy white to shades of blue, teal and green. Tobey also crafts contemporary and non-traditional sailor's valentines in many sizes and shapes. Thomas Brennan makes inlaid wooden jewelry boxes, using rare and exotic veneers and featuring contemporary and traditional motifs of seashells, lighthouses, floral and geometric designs.

As you go out their driveway, turn right. Walker Tapestry is two houses down on the right. The studio is the saltbox adjacent to the house.

WALKER TAPESTRY - 73
403 Stony Brook Road, Brewster
May thru September most afternoons til 4pm
(Unless the wind is right for sailing)
other times by appointment • 508-385-2621

Tapestry artist Patricia Walker, a twelfth generation Cape Codder, has been specializing in creating original hand woven tapestries for thirty-five years. Using ancient techniques and mixing yarns as if they were paint, she creates wonderfully flowing works of contemporary art. Her design process is experiential, and nearly always begins with the sea. Three of her public pieces may be seen at the Brewster Town Hall, and the Dennis Memorial and Jacob Sears Memorial Libraries. Selected works are available as prints. In addition to her own work and commissions, she teaches through the Cape Cod Museum of Art.

Retrace your steps to AP Newcomb, go left to Main Street, 6A. Turning right on 6A, you'll see the sign for Blue Jacket Studio and Gallery almost immediately. Take a left onto this dirt road (Blue Jacket), winding behind the Dillingham House on your left, (built by one of the earliest settlers of Brewster) and continue .2 miles to the gallery/studio.

BLUE JACKET STUDIO & GALLERY - 74
80 Blue Jacket Way, Brewster
June-September , Friday, Saturday and Sundays,
10am-4pm, 508-896-3353 • www.lizperry.com

There's a feeling of Old Cape Cod at this gallery hidden in the woods. Liz Perry and Carl Ahlstrom moved and rebuilt the historic Captain Wetherbee House and attached their studio to this site in 2001. The studio and separate gallery spaces offer a large selection of Liz's popular Cape Cod Shell Prints, Carl's seascapes and watercolors, plus linocut and collagraph prints, oils, and mixed media. Beautiful bird, fish and sea-related images are found among large and colorful award-winning monoprints. Liz created Brewster's Fall Open Studio tours, a not to be missed weekend in early October.

Turn left out of the driveway and Continue along 6A. Just past the Lemon Tree Village, you'll see a quaint cottage on the left which houses the twin studios of potter Diane Heart and her husband, photographer Mark Preu.

HEART POTTERY-PREU PHOTOGRAPHY - 75
1145 Main Street/Route 6A, Brewster - Year Round
Monday-Saturday, 10am-5pm
Usually closed Sunday except for busy holidays.
508-896-6189 • www.dianeheartpottery.com
www.preuphoto.com

For potter Diane Heart, there is no thrill like peering into a glowing kiln and witnessing a pot's transformation. She specializes in Raku pottery, the ancient Japanese firing technique that has its roots in the Zen tea ceremonies. Diane enjoys sharing her craft with visitors and can often be found at the pottery wheel. She works almost exclusively in porcelain, which lends itself to her carvings, glazes and textural additions. She shares her studio with her husband, photographer Mark Preu, who, using his life-long familiarity with the area, captures the fleeting moments when light, weather, and composition combine to make memorable images.

Continue east along Route 6A traveling about 2 miles to the next artist. You'll pass a yellow town building on the left, the old town hall. A little farther east on the other side of the street is the Brewster Ladies Library at 1822 Main Street. This library, founded in 1852, often uses its meeting room to display the work of local artists. In another quarter of a mile east is the Brewster General Store (1935 Main St./Route 6A), an 1866 former church, that now serves as the unofficial center of town. Parsons Art Gallery is not too much further on the left.

IS FOOD ART? You're at the right spot on the trails to see for yourself. Across from the East Coast Gallery and behind the Tru Value on Rte 6A, stop in and see Chef Paul at the Chocolate Peddler and his hand crafted truffles. He defines his all natural truffles as true bliss, and has as much fun having you taste them as talking about how he creates them. A box called Vacation Destination gives you truffles called Little Red Corvette, Cape Codder, Hot Date, the Nantucket and the Vineyard. Here's the Cape Codder: Cape Cod Cranberries & wild blueberries infused in white chocolate, cranberry toffee crunch, & hint of lime. A work of Art.

PARSONS ART GALLERY - 76
2109 Main Street/Route 6A, Brewster - Year Round
March-December, Tuesday-Sunday, 10am-5pm
From January-March, call first • 508-896-9014

Artist and potter Ken Parsons' gallery is right behind his home on Route 6A. In the gallery, you'll see award-winning paintings, scenics in watercolors, acrylics, and oils, as well as sculpture and pottery, including stoneware, porcelain, and raku, a traditional Japanese-style pottery. The works of raku have evocative names: a vessel called Ice Cap Eruption and a platter called Fragments of the Universe. The piece shown to the right, a raku fired, flared plate, is called Peninsulas. Ken, a friendly sort, is shown here firing his pots in the kiln behind the gallery.

Travelling east on 6A for 1 mile, you'll see East Coast Gallery on your left, with an entrance right before the gas station. This gallery combines Jeff Drake's architecture and design business with some wonderful three dimensional works.

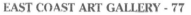

EAST COAST ART GALLERY - 77
2623 Main Street, Brewster - Year Around
May-December, Monday through Saturday
10am-5pm, Sunday 12pm-5pm
Other times by appointment
508-896-5600 • www.EastCoastArtGallery.com

Jeff Drake's light, airy gallery and studio serves both as a place where he creates three dimensional architectural reliefs, and a space hung with works by other artists on the trail, many with limited hours, a great way to check out stops on the trail in one place.The architectural reliefs are created with materials from old buildings since demolished or radically remodeled: a white barn in Barnstable Village, some beautiful practice shacks from western New York's Chautauqua Institution. Pictured here is a relief from the Jolly Whaler Village, razed in 2004 with the property added to Brewster's open space inventory. An easy person to talk with, ask him about his work creating graphics and scale models for trial exhibits, an interesting use of his highly developed three-dimensional talent.

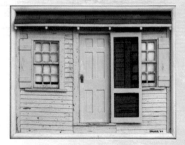

Continue less than .5 miles east and you'll see a modern building on the left, Aries East Gallery.

ARIES EAST GALLERY - 78
2805 Main Street, Brewster
April, Friday & Saturday, 10am-5pm,
Sunday, 12pm-5pm
May, June, September 15 to December 15 also
Thursdays, 10am-5pm June 30 to September 15,
Monday-Saturday, 10am-5pm, Sunday 12-5pm
508-896-7681

Geoffrey Smith is the artist-in-residence and owner of Aries East, a contemporary gallery displaying works by established local artists in various media including oils, watercolors, and pastels. The gallery shows landscapes, seascapes, and portraits. Geoffrey's work includes scenes of the American sporting life. His use of color, light and scenic elements create peaceful scenes of Cape Cod. Besides paintings, there are sculptures, prints, handcrafts and note cards, as well as custom framing.

A little further east and across the street is a wonderful studio full of calligraphy.

NICKERSON FAMILY ESTATE: Ocean Edge Resort & Club, once the Nickerson Estate, is listed in the National Register of Historic Places and is a spectacular landmark rich with New England history. About a mile away from the Mansion, you will find Nickerson State Park, once the private game preserve for the Nickerson family until they donated the land to the Commonwealth in 1934. Now called the jewel of Massachusetts' extensive state forest system, the park's 1,900 pristine acres are known and enjoyed by many.

CAPE LETTERING ARTS - 79
2814 Main Street, Brewster -Year Round
Monday-Saturday 10am-5pm
774-323-0050 • www.capeletteringarts.com

Cape Lettering Arts is the studio and gallery of former White House Chief Calligrapher, Rick Paulus. Rick's calligraphic prose and poetry of the sea capture the special qualities of season, light, and air on Cape Cod. A master calligrapher, Rick can turn your favorite poem or quotation into a work that resonates with the elegance and warmth of the human hand-or create for your special event an invitation that can't be refused! A charming selection of Rick's White House work is on display.

The next 2 galleries are within a mile, all on the right side of Route 6A. Heading towards Orleans, .2 miles is Stringe Gallery on the right, near Ocean Edge Resort & Club.

STRINGE GALLERY - 80
2806 Main Street, Brewster - Year Round
Daily 10am-5pm; June-October til' 6pm,
Closed Tuesdays and Wednesdays off season
Other times by appointment
508 896-5946 • www.stringegallery.com

Tom Stringe is known for his impressionistic watercolors and oils of florals, landscapes, and seascapes, and his beautiful gallery offers the perfect setting to enjoy the work. Tom brings an emotional quality to his paintings, in which flowers, saturated with color, take on added significance as expressions of joy, or, sometimes, solitude. The gallery doubles as an antiques store filled with attractive country furniture and accessories.

Continue .4 miles on Route 6A to Millstone Sculpture Gallery on the right. Just before Millstone Road, look for the sign made out of a large millstone. (Next page)

MILLSTONE SCULPTURE GALLERY - 81
3090 Main Street, Brewster - Year Round
June 1st-September 1st, 11am-5pm
Wednesday-Monday Other times by appointment
508-896-2452 • www.MillstoneGallery.com

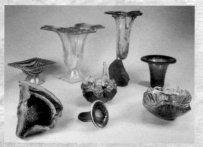

Millstone Sculpture Gallery is devoted to the internationally recognized artist Benton Jones. He opened the gallery in 1999 to showcase his innovative and daring work. With a desire to challenge and a passion for discovery, Jones has propelled his gallery to become a destination for serious art-glass collectors and lovers of art. Most recently, Mr. Jones refined a technique for melding glass with copper and brass. By possessing a deep understanding for the properties of both glass and metal, he has successfully fused them together, creating a dazzling spectrum of sculptures and vessels. You will also find outdoor sculpture, cast bronze, and forged metal work.

Go about a mile to Ruddeforth Gallery on the left.

RUDDEFORTH GALLERY - 82
3753 Main Street, Brewster - Year Round
Daily May-December, 10am-5pm
Call for winter hours • 508-255-1056
www.ruddeforthgallery.com

When the flag is up, Tom and Debra Ruddeforth's gallery is open. The gallery is attached to their house and next to it is the working studio. Debra, a signature member of Boston's Copley Society, paints richly-colored works in watercolor, oils and pastels. There are still-lifes, florals and landscapes, inspired by Cape Cod that have been displayed in the State House. One gallery room is full of Tom's black and white and color fine art photography, with images that capture the mood behind landscapes, like fog lifting over Nauset Harbor. Debra has loved painting since she took a field trip to an art museum in the second grade. When the teacher asked who wanted to stay overnight in the museum, she raised her hand.

Drive about .2 miles from Ruddeforth Gallery and look for the sign for Earth- n- Fire on the right, traveling up the driveway to the studio and gallery.

EARTH-N-FIRE POTTERY - 83
3852 Main Street, Brewster - Year Round
Daily, 9am-5pm 508-240-2529
www.earthnfirepottery.com

A husband and wife team comprise Earth-n-Fire Pottery, a combination art studio, gallery & residence along Route 6A. Andrew and Kathleen Jones create a range of pottery, a blend of the whimsical and the practical that is inspired by the environment of Cape Cod. Their clays range from stoneware to high fire porcelain. Visitors to the gallery see the wheels and kilns on the first floor; the pottery gallery upstairs is decorated with vintage movie posters, quilts and fine crafts. This is also the home of the Cape Cod Seagull, a pottery statue that will surely make you smile.

Struna Gallery is on the left as you continue driving east into Orleans.

STRUNA GALLERIES - 84
3873 Main Street, Brewster - Year Round
Daily, 11am-5pm
January 1-March 30,
Friday-Sunday, 11am-5pm • 508-255-6618
www.strunagalleries.com

In an antique carriage house surrounded by country gardens, Tim and Barbara Struna have created Struna Galleries, featuring the oil and acrylic paintings, watercolors, limited edition prints, and copperplate engravings of Timothy Jon Struna. Tim's work, which he calls "traditional realism," is inspired by the beaches, marshes, and architecture of Cape Cod. Tim and his wife Barbara love to share information about the process of printmaking and watercolors. In season, they have behind-the-scenes events to educate the visitor. Off-season, they offer personalized explanations about the processes. Some of the displayed work actually depicts the printmaking process, revealing how the plate is made.

The next artist is located approximately .25 miles further east on Route 6A on your right.

HANDCRAFT HOUSE GALLERY - 85

3966 Main Street (Route 6A), Brewster
April 15-December 31, daily 10am-5pm
January-April 14, Wednesday-Saturday 10pm-5pm
508-240-1412 • www.handcrafthousegallery.com

Featuring the fanciful creations of inspired craft artisans, the HandCraft House offers a collection of pottery, jewelry, scrimshaw and photographs by talented Cape Codders. A variety of materials including domestic and exotic woods, metals and fabrics are fashioned into decorative and functional art. There are examples of stained, blown, fused, beveled, and extruded glass including pendants made of glass from the historic Sandwich Glass Company. Watercolor artist and gallery owner Eileen Smith exhibits her paintings and prints that capture Cape Cod and its seasonal moods.

Continue east on Route 6A, .6 miles to the first traffic light, where you'll turn right onto Bakers Pond Road. Go up the hill .3 miles, and take a left onto Doran Drive, #3 is the first house on the left, for Paletteworks.

PALETTEWORKS - 86

3 Doran Drive, Orleans-Year Round
Daily, 10am-5pm, or call for appointment
1-866-ARTMAN-1 or 508-737-7788
www.artman1.com

Slightly off-the-beaten path is the painting studio of Stephen Roth. Steve's studio, where he creates his work, is right next to his house. He works with a palette knife rather than a brush. In a style blending impressionism and realism. Over the past 15 years he has created customized knives to achieve special effects. The non-traditional paintings are primarily floral and landscapes that he calls fragment paintings. His wet-on-wet, rapid painting style creates an unusual vibrancy. The images reach out to you.

Retrace your route back onto Route 6A and continue right into the center of Orleans, about one and a half miles straight along 6A. At the second light, you'll be at the intersection of Main Street. Turn left and then enter the parking lot on the right, just before Mahoney's Restaurant. You'll be well positioned to visit the next grouping of galleries in downtown Orleans.

First, head over towards Hole in One and walk up to Rte 6, cross the street and near the Village Pizza, you'll see Jewelry by S&R on the left.

JEWELRY BY S & R - 87
85 Rte 6A Lowell Square, Orleans - Year Round
Tuesday- Saturday 10am-5pm
508-240-3608 • www.jewelrybysr.com

Jeweler Steve Drysdale creates unique designs from the traditional and antique to the modern with silver, gold, gems and precious stones. A certified bench jeweler, Steve uses old world craftsmanship to help customers to create their own "heirlooms;" a picture of a pet made into a charm, a custom wedding or engagement ring, a necklace made with hand forged wires of gold or silver with a stone from a special trip, and demonstrates the process for them in his workshop: With great attention to detail, Steve's own designs are truly pieces of art, while also offering a wide selection of more traditional hand crafted pieces.

PRINTMAKING: Beginning in the 15th century, artists began using printing presses to create multiple copies of drawings, and the art of printmaking was born. On the Cape and Islands, artists have long been innovative in the art of making original handcrafted prints. These are very different from the modern giclees. In the early 20th century, a group of artists based in Provincetown developed the art of white-line woodblock prints, which were influenced by Japanese prints. Other printmaking techniques used widely in the region include etchings, lithography, monotypes, silkscreening (seriagraph prints), woodcuts, and other forms of relief prints. Printmakers take pride in their work and will often show visitors exactly how the pieces are made.

Returning through the parking lot, you'll see Coastal Craft Gallery next to Oceania.

COASTAL CRAFT GALLERY - 88
2 Main Street Sq, Orleans - Year Round
Monday-Saturday 10-5, 11pm-4pm on Sundays
508-255-0220 • www.coastalcraftgallery.com

This beautifully organized co-op gallery creates a wonderful stop where you can see a wide range of work in one location. Brightly lit cabinets contain stained and dichroic glass, jewelry, pottery, sculpture, and mixed media, The shelves hold hand bound albums and books, marquetry boxes, cards and collages. Some artists' work is grouped together, while others have work intermingled to create an interesting display. There are leather and textile bags and fabric clothing, and unusual shell creations, :from unique sailor's valentines, to beautiful wreaths, mirrors,and lamps. The 15 members are Delia Ayleshire Quinn, Tobey Hirsch Brennan, Thomas Brennan, Sue Clark, Nancy Craemer, Liz Perry, Donna Helfen, Richard Kaish, Kathy Meyers, Nancy Pendergast , Doris Riddle, Ellen Scott, Stef Semple, Chris Shand, and Nancy Simison.

Heading out to Main Street (right out of the door and through the driveway), cross the street to Gallery 31.

CAPE LIGHT: What is it about the Cape quality of light that attracts so many artists to this region? Is it the flat sharp light on a high summer afternoon, the foggy haze of a spring day, the autumn's clear mauve light or the pale frosty light of early winter? Many painting teachers in the early days of Provincetown's art colony took their students out to the beaches, piers, and streets of town to paint in "plein air," outside in the clear light to take advantage of this unique quality. Today's artists do the same.

GALLERY 31 FINE ART - 89

31 Main Street, Orleans - Year Round
Daily mid-April to mid-October; 10am-5pm
Daily, July and August, and
Fridays and Saturdays til 7pm
Off season long weekends. Otherwise open by
chance or call for an appointment.
508-247-9469 • www.gallery31capecod.com

Gallery 31 Fine Art for Your Home and Your Heart, features the paintings of Cape Cod artists. Located in the Old Orleans Post Office, look for Pierre, a papier maché sculpture, sitting on the gallery bench next to the bright yellow door. Established in 2000, Gallery 31 features two rooms of paintings including landscapes and still lifes in oil, pastel, watercolor, and acrylic, as well as tile art and jewelry Artists Lora McNeece Barrett, Todd Bowman Ash, Tilda McGee Bystrom, Robina Carter, George Corbellini, Maureen Leavenworth, Pat Martin, Sherry Rhyno, Marilyn Schofield, and Laurel Wilson own and manage the gallery as partners and provide an eclectic mix of styles to satisfy any collector. You might find an artist working at an easel in the gallery as you browse. Opening Receptions are open to the public and held on alternate Saturdays from 4 to 7pm in season.

Cross through the Traffic light, over Rte 6A. In the first grouping of buildings on the right, you'll find Honey Candle. (next page)

HONEY CANDLE COMPANY - 90
37 Main Street, Orleans - Year Round
Monday-Saturday, 10am-5pm
508-255-7031

Agostino DiBari came to this country from Italy where he was trained in the art of ceramics. He uses that experience to create unique molded beeswax candles, in addition to an array of tapers with a wide variety of shape and color. Beeswax is non-toxic, naturally aromatic, and emits beneficial negative ions when burned, producing a calming experience. Agostino, who is self-taught in the art of candle-making, is always there. He'll tell you about the history of beeswax candles and the process, and you can see right where he makes them. He's a true artisan, creating functional and unique candles "made under the Cape Cod sun."

Right across the street, above The Orleans Whole Food Store, stop in to see Bob Korn, a local who's a national resource on the giclee process.

BOB KORN IMAGING - 91
46 Main Street, Orleans - Year Round
Monday-Friday 10am-5pm
508-255-5202 • www.bobkornimaging.com

Just to the left of the Whole Food Store is a door that leads to the second floor studio of Bob Korn. Bob works developing fine art photographs and giclee prints. This is the place to go if you want to talk with someone about the art of photographic and digital printmaking. He produces what many artists have hanging in the Getty Museum, Smithsonian, MOMA and others, and is involved in a major collaboration with ArtWorks! (see page 96) on the Rowland Scherman Project, preserving this photographer's historic images of icons of American history and music. Visitors can check out his class offerings, rent his darkrooms, and talk to a pro in moving from traditional wet darkrooms to the digital age.

Here you need to head out of town for a slight detour to an award winning weaver. Following Main Street past Friends Market and Post Office Square, go through the traffic light as if you're heading to Nauset Beach. Continue through the second light at Tonset Road, and across from the Academy Playhouse look for Monument Road on your right. Turn onto Monument, and continue .2 miles. The next gallery is the third house on the left, #33: When the sign is up, she's open.

TANZER FIBER WORKS - 92
33 Monument Road, Orleans MA 02653
June and September,
Saturday and Sunday 11am-4pm
July and August, Friday-Sunday 11am-4pm
508-255-9022 • www.tanzersfiberworks.com

Entering Gretchen Romey-Tanzer's airy studio, the visitor sees beautifully woven textiles of all sizes on the walls above her two looms. Manipulating colors, she creates work with graduated tones that looks very simple, but is very sophisticated. Small weavings demonstrate Gretchen's contemporary interpretation of the images that inspire her. With awards and invitations to national and international exhibitions, you may have seen her wall hanging that now hangs in the Boston Museum of Fine Arts' permanent textile collection. Her weaving room and music room are one. Gretchen plays violin with the Cape Cod Fiddlers and a Norwegian Hardanger fiddle with the Boston Spelemannslag.

Returning back to town through the two lights, turn right at the second light, Rte 28 . Addison Art Gallery is one block up on the right side of the street. (Next page)

ADDISON ART GALLERY - 93
43 Route 28, Orleans - Year Round
10am-6pm
1-877-291-5400 toll free • 508-255-6200
www.addisonart.com

Highly respected for representing intriguing emerging and established artists, the Addison Art Gallery offers exceptional service in the comfort of a charming red half-Cape. Oils, egg temperas, pastels, watercolors, giclees and sculptures from across the U.S., Central America and France. Depicted here is a work by Logan Hagege. With an ever-changing selection of superb art and a full schedule of opening receptions, Addison Art is considered one of the nation's finest galleries. Visit their website to view their available inventory and then stop by the gallery to truly enjoy all that they have to offer.

Leaving Addison Art Gallery, turn right onto Rte 28 and travel until it joins with 6A. Immediately after the merge, turn right into the Double Dragon parking lot. At the left rear you'll find Artworks!

ARTWORKS! - 94
57 Route 6A, Orleans - Year Round
July-December, Tuesday-Saturday, 10am-5pm
January-June, Thursday-Saturday, 10-4pm
508-255-1187

Enter Artworks! for a totally different art experience. Meri and David Hartford have used their long history of working with local artists to create a place that transcends the walls of the traditional gallery. Artists are driven to express themselves through their art, but the viewer is often left with unanswered questions- why, where and how? By creating a multimedia audio and visual presentation about a single local artist, the visitor has a deeper connection with the artist and the viewer, exploring the artist as well as the art. The entire project started with their collaboration with Bob Korn Imaging around the Rowland Scherman Project, preserving and exhibiting his iconic photographs of the 60's and 70s. The presentations focus on different artists throughout the year.

Turning right out of the lot, pass the windmill, continue through the light and Kemp Pottery will be on the right.

KEMP POTTERY - 95
9 Cranberry Hwy (Route 6A), Orleans - Year Round
Monday-Saturday, 10am-5pm,
June-September, also Sunday 11am-4pm
508-255-5853 • www.kemppottery.com

Kemp Pottery is a studio/gallery owned and operated by Steven and Matthew Kemp. Father and son collaborate in wheel-thrown and hand built stoneware and porcelain, both functional and decorative ware, as well as abstract and figurative sculpture. Using drawing as a base their work includes various decorating techniques, themes and designs: sgraffito, sumi-brush technique, graphic storytelling and more, to create distinctive objects. Steven's work reflects his observations of the Cape's wildlife, flora, and seascape. Mathew's work intrigues, reflecting his interest in comic art as well as the fears and foibles of the human condition. Steven and Matthew forge a bond through "art as life", while nurturing an environment of mutual creativity.

Take a right out of Kemp Pottery, and go around the rotary to the sign for the Court House and Rock Harbor. Follow the directions to Rock Harbor on Rock Harbor Road. Go a little over 1 mile, winding past the marshes to the harbor. Head towards the boats going past the left turn onto the continuation of Rock Harbor Road, and you'll see Priory Gifts, on the left within the Community of Jesus complex. (Next page)

JONATHAN YOUNG WINDMILL: The Jonathan Young Windmill (Route 6A, next to Orleans Town Cove), was built in the early 1700s. The historic site is manned in summer by actual millers who explain the history of the mill and the centuries-old profession.

PRIORY BOOKS & GIFTS AND PARACLETE HOUSE - 96

5 Bayview Drive, Orleans - Year Round
10am-5pm; Closed Wednesday and Sunday
Also Closed Memorial Day, July 4th, & Labor Day
September 1st-September 15th and
January 1st-January 15
508-247-3194 • www.priorygifts.com

For an ethereal gallery experience, head to Priory near the Church of the Transfiguration. As you enter into the church complex, you'll see clearly marked signs to Priory, which is in the Paraclete building. The art display includes mosaics, oil paintings, calligraphy, weaving and stained glass. On Fridays, there is an artists' talk and a tour of the magnificent church, complete with Italian frescos and mosaics. The shop itself has a range of products, including books, cards, soy and beeswax candles, weavings, soaps, and CD's.

As you exit the complex, make a right, then another quick right onto Rock Harbor Road. Rock Harbor Gallery will be the fourth house on the left, with the barn housing Kely Knowles' work set back from the road.

ROCK HARBOR GALLERY - 97
104 Rock Harbor Road, Orleans - Year Round
May thru October
Tuesday-Saturday, 1pm-5pm
Other times by appointment
508-255-3747• www.capewatercolors.com

Artist Kely Knowles has designed a beautiful Old Cape Cod-style space that fits with the ambience of Rock Harbor. There are original watercolors, giclee prints, cards, and tiles in the barn next to her house. The subject matter is of and about Cape Cod, antique Capes and summer houses, peaceful ponds, colorful flowers, children in the sand, skiffs lying along a beach. Kely creates an array of tones that interpret the Cape Cod palette. A firm believer in the support of others, Kely provides open studio hours for groups of painters who want to paint together, something to explore with her when you visit.

Leaving the gallery, make a left and continue .4 miles to Skaket Beach Road. Go Right .4 miles. At Ellen Walker square bear left. This road becomes West Road. The final gallery, Sea Shell Pottery should not be missed. It's off the beaten path, but worth a stop. Look for the wooden sign with the shell at #95 and turn in between two large trees.

SEA SHELL POTTERY - 98

95 West Road, Orleans - Year Round
May-September
Tuesday-Saturday, 10am-4pm
October-May, by chance or appointment
508-255-7138 • www.seashellpottery.net

Mikael Carstanjen of Sea Shell Pottery and his wife, Mary Doering are well known in the region for their exceptional artwork. As you turn into the lily-lined driveway, you'll see the studio/gallery right in front of you, which was recently doubled in size, in the middle of an array of buildings and lovely gardens on the property. Mike and his wife, Mary, make you feel welcome, showing you their workspace and talking about the inspiration for their pottery and photography. Mikael has been crafting pottery for 31 years, but he continues to innovate. In the latest venture for the couple, Atlantic Tile and Design, original photos, bold and striking, are printed on ceramic tiles. With their barn renovations, you can also now see Mikael at work in his digital studio.

ARCHITECTURE

Many galleries and art studios on Cape Cod are housed in historic barns and carriage houses, so an art tour around these parts can also become a tour of Cape Cod architecture.

Architecture in this region begins with the "Cape Cod House," often called simply a "Cape." The term refers to a wooden, one-and-a-half story shingled home with a central chimney. The first Cape houses were built in the 17th century by European settlers. You can see more early examples along the Old King's Highway/Route 6A. In fact, Route 6A,which winds through seven Cape towns, is not only a wonderful place to find art studios and galleries, it is also a great place to look at interesting examples of historic architecture. Drivers on this charming road will see a range of styles, particularly grand Sea Captain's homes built in the colonial style, many of which are now Inns.

Georgian Colonial homes were popular in the 18th century and tend to be two-story square and symmetrical houses with two chimneys, one on each end of the roof. A good example of this style is the Cahoon Museum of

Art on Route 28 in the village of Cotuit in the town of Barnstable. Federal-style colonial homes have classical elements like columns at the front door. The Julia Wood House, which houses the Falmouth Historical Society on the Village Green in Falmouth, is a good example of this style. Greek Revival-style homes popular in the mid-19th century mimic Greek temples with doorways bounded by carved columns and friezes above. The Addison Art Gallery on Route 28 in Orleans is an example of this style. There is also the Second Empire style, which features mansard roofs and elaborate carvings. The Captain Penniman House near Fort Hill in Eastham is an example of this style. Everyone seems to delight in the Carpenter Gothic style of "gingerbread" houses that were popular in the late 19th century Victorian period. The most famous examples of this style are in the Methodist campground on Oak Bluffs on Martha's Vineyard.

The Outer Cape is a study in contrasts. There are the pristine stretches of beach in Eastham, the small town charm of Wellfleet; the large farms of Truro, and then there is Commercial Street in Provincetown, which is arguably the liveliest main street north of Key West. The contrast of this unique natural beauty with an artists colony, a gay resort, supreme beaches and nightlife is what draws large numbers of people to Provincetown and Outer Cape towns. Besides visiting the artists of the Outer Cape, travelers may want to

discover the region by hiking, biking or kayaking.

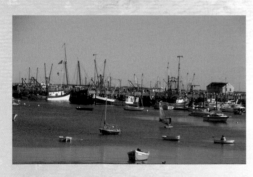

This area was saved from over-development by the foresight of former President John F. Kennedy and others who fought to preserve vast stretches of coastline as the 27,000-acre Cape Cod National Seashore. The Seashore Visitor Center along Route 6 in Eastham is a good first stop to learn about the geology of this evocative land of sand and scrub pine. A stroll through Wellfleet, which calls itself the art gallery town, will take visitors past a number of fine galleries along Wellfleet's Commercial, Main and Bank streets.

In Truro, the Cape's smallest town with about 2,000 year-round residents, land along the coast is mostly

Trail 7
Great Dunes Trail
Wellfleet to Provincetown

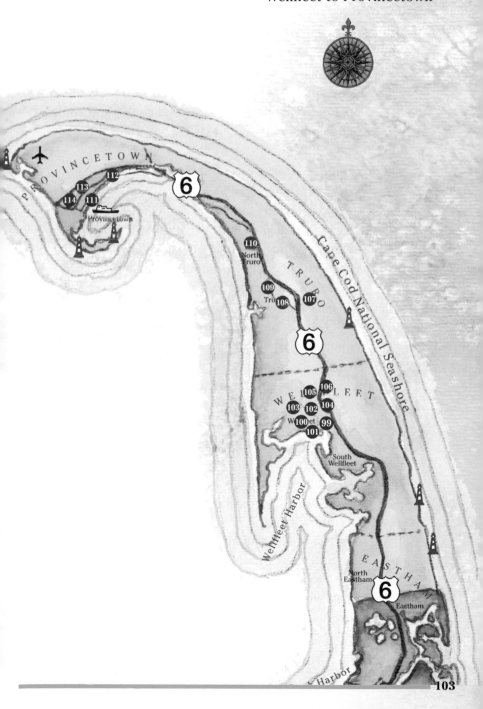

preserved by the National Seashore. In tiny Truro village is the Castle Hill Center of the Arts, where you might find a Pulitzer Prize winner teaching a poetry class. True bohemian rhapsody can be found in Provincetown at the end of the road, the last town on Cape Cod. From the first time you see the massive shifting sand dunes along Route 6, you'll know why countless artists over the past hundred years have been inspired by this town at the Cape's tip.

How To Use This Trail

The Great Dunes Trail has the most spread out town centers, lending itself to multiple visits. It starts in Wellfleet, with galleries on the way in and out of town and near the town center—providing an opportunity to wander through this beautiful village. Saturday night in season is gallery night. Visiting Truro is easiest on your way to Provincetown. Follow the directions carefully, as road markings are occasionally on trees. Plan on walking around Provincetown, an arts destination in itself. Find a place to park, stroll up and down Commercial Street before heading off Bradford Street to the Fine Arts Work Center. Pick up the Provincetown Art Guide to see what galleries are offering this year. Our in town listings take you to the institutions that anchor the arts community in the region and keep this world class arts destination solid. With so much happening, pick up the Banner, Provincetown's local paper, for the most up to date schedule of arts events.

CAPE COD NATIONAL SEASHORE

Since the Cape Cod National Seashore was established in 1961, millions of visitors have walked barefoot on its 40 miles of public beaches saved forever from development. Besides beaches, there are three bike trails and many walking paths in the Seashore's 27,000 acres, which stretch from Provincetown to Chatham. Two visitor centers, in Eastham and Provincetown, are open to the public. But the National Seashore preserves more than the Cape's natural beauty—the beaches, marshes, dunes and forests along the coast. Seashore rangers work to show visitors the Cape's human history too. In Provincetown, visitors can see where

the Pilgrims first landed in 1620 before sailing across the bay to Plymouth. Also within the National Seashore are several historic buildings open to the public: the Old Harbor Lifesaving station on Race Point Beach in Provincetown; Captain Edward Penniman's grand Second Empire-style house in Eastham; the 18th century Atwood-Higgins House in Wellfleet, and five historic

lighthouses. Many of these buildings, including Nauset Light, are open for tours in the summer. For more information, check out www.nps.gov/caco.

Great Dunes Trail

This trail begins in Wellfleet, the Art Gallery town. You can start or end your visit with Narrow Land Pottery, on your left just across from the Wellfleet Center and Harbor Sign. Turn left at the traffic light where it says "Wellfleet Center." You'll find Kendall Gallery, the third building on the right. This stop will give you a real sense of tranquility after driving on the highway.

KENDALL ART GALLERY - 99

40 Main Street, Wellfleet
Daily 10pm-5:30pm
May-October 1, and Sundays 12pm-4pm
Artist reception Saturday evenings, Summer
October 1-Columbus Day, call for hours
Off-season by appointment
508-349-2482 • www.kendallartgallery.com

Walter and Myra Dorrell met in the dunes of Truro many years ago when Walter, a watercolor and pastel artist, was painting a scene. Together they operate Kendall Art Gallery, which features the work of 40 artists. Besides paintings, there are bronze, steel and marble sculptures, as well as ceramics and jewelry. Work is displayed in a Greek Revival-style house, and also in the large airy "outback" gallery. Gardens, including the secret garden behind the gallery, are the site of displays of sculpture, fountains and garden art.

Continue along East Main Street, bearing right at the fork. Head toward town. Park at town hall on your right, cross the street, to Brophy's Fine Art. If you like to walk, you can get to the next few galleries from the center of town, or you can follow the driving directions.

BROPHY'S FINE ART - 100

313 Main Street Wellfleet - Year Round
Daily July & August 11am-9pm
Sundays 11am-4pm
September and June Daily 11am-4pm
Off Season Weekends As well by chance
and by Appointments
508-349-6479 • www.brophysfineart.com

Tom Brophy has been working with stained glass for over 25 years. His works are created in both his home studio and his gallery on Wellfleet's Main Street. The pieces are notable for their vibrant colors and imagery of familiar Cape Cod scenes: a blue heron, a cluster of ladys slippers, a bouquet of irises, or even a view of waves breaking offshore. The Gallery also offers an incredible collection of oil paintings by prominently noted Cape Artists. In its 11th Season, this is a must see Gallery for seasoned collectors, first time buyers and for those who appreciate fine works of art.

HARMON GALLERY

95 Commercial Street, Wellfleet
May 1-June 1, Wednesday-Sunday, 10am-5pm
Daily 10am-5pm June-August
September-December, call for hours
508-349-0530 • www.harmongallery.com

Located in the old Mooney Fuel and Grain building is Harmon Studio Gallery, run by artists Traci Harmon-Hay and Vincent Amicosante. The gallery space is two levels with a light, airy, modern feel. The top-level studio, where Traci and Vincent do their work, is also open to the public. Besides their own artwork, their gallery represents over a dozen local artists, including painters, photographers, and sculptors. The gallery's shows, including a small works show, reflect Traci and Vincent's connection to the community, making art affordable for all income levels.

Turning right, go .2 miles back toward Route 6 on Commercial Street. Where it intersects with Bank Street you'll see the Wellfleet Customs House on the right, now a pottery studio. Built in 1858, it served as a combined storehouse for the hardware store and Customs Collection Office for the Town. Find a place to park for the next two stops.

ANDRE POTTERY STUDIO - 102
5 Commercial Street, Wellfleet
Daily Memorial Day-Labor Day, 10am-12pm
and 2-6pm
Spring and Fall weekends.
508-349-2299 • www.andrepottery.com

A potter for over 35 years, Peg Andre's work is eclectic and functional. Her studio is located in the renovated Wellfleet Customs House. Peg makes a range of stoneware pottery, including vases, pitchers, bowls and casseroles. She also makes hand-built pottery pieces, including sculptures and serving dishes. In addition to two working kilns and an active pottery, the studio features an outdoor sea-garden perched over the saltwater estuary, Duck Creek. Inside the studio, Andre's work is displayed on driftwood and sand from the nearby beach.

The next artist is across the street, up a slight hill on Bank Street. Go into the first parking area. The Jewelry Studio of Wellfleet is in a small building in the rear of Jules Bensch.

JEWELRY STUDIO OF WELLFLEET - 103
15B Bank Street, Wellfleet
Daily June to October 10am-6pm
extended hours in July and August
May, November, December
Thursday-Sunday 11am-5pm
508-349-2284 • www.jewelrystudiowellfleet.com

Visit the working studio and gallery of artisan and jeweler Jesse Mia Horowitz. Growing up on Cape Cod has influenced Jesse's unique jewelry designs. Her flowing jewelry captures the movement of water and wind. It has an organic quality resembling vines and seaweed. Working predominately in sterling silver and gold, many pieces incorporate beautiful gemstones, pearls and wampum found on Cape Cod beaches. One of her most popular pieces is the famous Wellfleet oyster, cast from the real thing, along with an assortment of other shells. The Jewelry Studio gallery, tucked just off charming Bank Street, also carries the work of several other local jewelers and has its own parking.

Getting back onto East Commercial Street, continue away from the harbor. Pass by Uncle Tim's Bridge, and at the intersection with East Main Street is Gallery 5 on the right facing the "Welcome to Wellfleet" skiff. Parking is available.

GALLERY 5 - 104

5 East Commercial Street, Wellfleet
July-October, Monday-Thursday, 12pm-5pm,
Friday & Saturday, 12pm-8pm, Sunday, 12pm-5pm
Year Round open by appointment
508-349-5855 • www.nancynicol.com

Nancy Nicol, painter and sculptor, brings depth of feeling and personal imagery to the surface, whether wood, canvas or paper. Gallery 5 is her studio/gallery/home and all artwork is unique and produced on-site. She is known for large luminous oil-on-paper landscapes, abstract collage cartography and custom-made feline portrait sculptures. Her recent work illustrates a Darwinian interest in Arthropods-beetles, moths, and horseshoe crabs. She is a member of the Provincetown Art Association and Museum, the Wellfleet Art Gallery Association and the Organization of Independent Artists.

A little further on the same side of the street is Salty Duck Pottery.

SALTY DUCK POTTERY - 105

115 Main Street, South Wellfleet - Year Round
Daily 9am-4pm or by appointment
508-349-6852

The pottery studio and shop of Maria Juster and Katherine Stillman is located directly on the salt marsh, Duck Creek, an ever-changing scene of plants and wildlife unique to Cape Cod. The ebbs and flows of the creek, creating a different and constantly evolving scene every hour and every season, serve as inspiration for the potters who create their work at Salty Duck. Pottery is produced on the premises year round. Potters Maria and Katherine make functional and artistic stoneware pottery for daily use. They also create handmade tiles.

Head out to Route 6 and turn right for one last stop in Wellfleet you shouldn't miss. Narrow Land Pottery is on your right. Just past the gas station.

NARROW LAND POTTERY - 106
2603 Route 6 Wellfleet - Year Round
Daily Memorial Day-June 30, 10am-5pm
July 1-Labor Day, 10am-6pm
Labor Day-Columbus Day, 10am-5pm;
Closed Tuesday Columbus Day-Thanksgiving
Weekend, Open Saturday; Closed Sunday
Other times by chance or appointment
508-349-6308 • www.narrowlandpottery.com

Joe McCaffery has been making pottery on Cape Cod for almost 20 years. At Narrow Land Pottery he displays his functional stoneware and decorative porcelain. Rich glazes and classic shapes are combined resulting in gorgeous one of a kind works of art. Lamps, planters, vases, bottles, bowls, casseroles, teapots, platters, a wide assortment of dinnerware and pieces for the kitchen are available. Among the glazes he uses are celedon, copper blue, stony matte, shino, crackle, and his distinctive blue and burgundy stoneware glaze. A constantly changing inventory of pottery means that each stop at Narrow Land Pottery is a new experience.

Continue east on Route 6 to Truro, the smallest town on the Cape, to see three very different but wonderful studios as well as an important arts center. Take the Pamet Road/Truro Center exit, turn left onto North Pamet Road. In .2 miles take a left on Avery Way. Drive another .2 miles, take left on Swale Way (dirt road). Go to #6 at the top of the hill, on the left. Turn the corner and pull into the upper driveway. You'll see a beautiful new building that houses the studio and gallery of Cameron Watson.

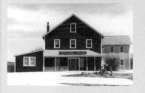

HOPPER: While driving around the Outer Cape towns of Truro and Provincetown, fans of Edward Hopper may get a feeling of déjà vu. A number of vistas that Hopper painted remain the way they looked about 70 years ago when he set up his easel: the side of a road in Truro to paint a gas station, or on Bradford Street in Provincetown to paint a bed and breakfast. Hopper's simple clapboard house still exists on a Truro bluff, with its large north-facing window that gave the famous artist the crucial light he needed to paint. Go to the Highland House Museum, pictured here, from June 1 through September 30 to get more information on Hopper in Truro, as well as other interesting local history.

N. CAMERON WATSON - 107

6 Swale Way Truro
Memorial Day-Columbus Day
Wednesday 9am-noon
Other times by Appointment
508-349-6747
www.ncameronwatson.com

Years of planning went into the creation of Cameron Watson's studio, and at 30'x30', it is probably one of the largest on the Cape. Cameron included features of studios she has admired over the years. Foremost is perhaps the wall of huge windows on the north side of the studio and the cathedral ceiling, both of which allow her to work in natural light. Cameron, a third generation artist, is a former children's book illustrator. She now works in oils, watercolors and sumi-e.

As you retrace your steps to Pamet Road, turn right and follow it under Route 6 towards Truro Center. You will be facing Duarte Downey Realty on Truro Center Road. Make a left, then immediate right onto Depot Road, Castle Hill Center for the Arts at Pamet Crossing will be on the right. Go slowly. The driveway to # 3 and #5 Depot Road is a dirt road up a hill, immediately past the parking lot at Castle Hill. Follow the signs up the driveway to the studio. In the nice weather you'll see the pots scattered on the lawn between the 1830 farmhouse (where the artist paints the pots) and the studio.

JOBI POTTERY - 108

3 Depot Road, Truro - Year Round
Daily 10am-5pm, May 1st-October 31st
November-December, Thursday-Sunday 10am-5pm
Closed Thanksgiving and Christmas,
January-April, Fridays and Saturdays, 10am-5pm
Other times by appt. or chance
508-349-2303 • www.jobipottery.com

Susan Kurtzman is carrying on a Truro cottage industry in making "Jobi" pottery, which is hand-painted slip-mold pottery made from original mid-century molds. The pottery was first made in 1951 by Joe Colliano and Bill Hastings, who worked out of a summer shack near Truro's Highland Lighthouse, and then by the Locke family. Now Susan continues the tradition and gives tours of the studio. Susan hand-paints the pottery, often using new bright colors and contemporary designs to compliment the older designs. She also creates new designs based on older pieces, combining retro designs with the traditional Jobi cattails, blueberries, birds, fish, and lighthouses.

Turning left out of the driveway, turn left again on Truro Center Road, going past the Downtown Truro sign. Take the next left at the fork, Castle Road, and follow it towards the bay (.5 miles). Across from the triangle with the flagpole, you'll see the cluster of buildings that make up the Truro Center for the Arts at Castle Hill.

TRURO CENTER FOR THE ARTS - 109
AT CASTLE HILL
1 Depot Road, Truro - Year Round
Monday-Friday, 9am-5pm
508-349-7511 • www.castlehill.org

In 1971, a group of Outer Cape artists took over the former Snow Stables property, with its 100-year-old barn, saving it from demolition. Ever since, the property, with its distinctive tower, has served as the headquarters for Castle Hill, an arts center in the heart of Truro. The mission of Castle Hill is to foster the arts and crafts by providing a wide range of instruction for adults and children. Castle Hill holds exhibitions, lectures, forums, concerts, and other activities to promote social interaction among artists, craftsmen, laymen and the community. The Center's annex at Pamet Crossing, less than a mile from the center headquarters is used for winter programs. Over the years, Castle Hill has provided top-notch programs and classes featuring distinguished nationally known cultural leaders. Besides numerous arts and writing classes, there is a printmaking cooperative and a ceramics cooperative, and Brick Kiln. (p. 114)

Turning left out of the driveway, follow the road, passing straight through the stop sign to Rte. 6. Then turn left towards Provincetown. Go about 2 miles on Route 6, and right past the Seaman's Savings Bank you'll see a sign on the left for the Truro Tradesman's Park. The Guild of Fine Glass Artists is in Unit 7, towards the rear of the large building. Look for a flag near the door, and be prepared to see a wonderful, full working studio with two dynamic artists.

THE GUILD OF FINE GLASS ARTISTS - 110
HOME OF THE TRURO ARTISTS
COOPERATIVE

352 Rte. 6 N. Truro - Year Round
Monday, Thursday, Friday 10am-4pm,
Saturday and Sunday 12pm-5pm, by appointment
Tuesday and Wednesday
508-364-5417 and 774-487-1195
www.taqwaglassworks.com
www.donna@donnamahanstudios.com

Christie Andresen of Taqwa Glassworks and Donna Mahan of Donna Mahan Studios share this working studio and gallery. Christie combines skills from years of jewelry making and leather working with traditional stained glass application, creating panels with open areas of hand sculpted brass and copper, fused and kiln fired glass, and relief motifs that seem to move with the shifting sunlight. Sculptural aspects of hand wrought metals and kiln fired glass transforms the panels with ambient light. Donna's work reflects her previous work in a range of artistic mediums, as she creates sculptures with a wide range of found objects of brilliant textures and colors of glass. Bringing numerous objects together, her art speaks of life's stories like a patchwork quilt. The use of metals, wood, shards, wire, depression glass, shells or fused glass remnants all add to the magical sense of movement, history and the mystical.

Continuing on Shore Road, take Route 6A into Provincetown. You'll see a fabulous view of Provincetown Harbor. At the fork, bear left onto Commercial Street. Continue down Commercial Street. It is a one way street and parking is tight. Park at MacMillan Wharf. Walking past the MacMillan Wharf and the center of town, pass the town hall and head towards the Whaler's Wharf. The Artisan Cooperative is on the second level. (Go to Page115.)

THE WOOD-FIRED KILN AT HIGHLAND CENTER AT THE NATIONAL SEA SHORE

For pottery enthusiasts, nothing beats a wood-fired kiln. Magnificent colors, along with textures and patterns that are gloriously irregular, are the hallmarks of this firing method. That is why area artists are particularly excited about the new wood-fire kiln at Highlands Center at the National Seashore. Now making pottery in the Outer Cape is truly a community

affair, as members of the public can participate in kiln firings by signing up for classes at Castle Hill. The wood-fired kiln, the first on Cape Cod, is a partnership between the Truro Center for the Arts at Castle Hill, which manages the kiln, and the Highlands Center, where the kiln is located at 21 Dewline Road in North Truro. The special wood-fired kiln was built with the help of local potters after a workshop with master kiln builder Donovan Palmquist in September 2008. Mr. Palmquist has built nearly 200 kilns, including 20 custom wood-fired kilns like the Truro one. Firing a wood kiln takes patience, faith and most importantly time. Each firing takes about 42 hours and uses two to three cords of a mixture of hard and soft wood. During the firing, the kiln must be watched and the wood

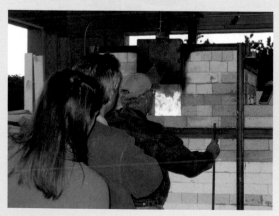

needs to be stoked and tended. Castle Hill offers approximately four to six firings on the wood kiln per year, twice each in the spring, summer and fall. Anyone interested in firings at the wood kiln can call Castle Hill at 508-349-7511 or go to www.castlehill.org.

PROVINCETOWN ARTISAN COOPERATIVE
237 Commercial Street - Year Round
Daily, May-December, from 11am
January-April, weekends Call for hours
508-487-9383 • www.provincetownartisancoop.com

After the old Whaler's Wharf was destroyed in a fire several years ago, it was reconstructed as a place that could provide affordable studios for artists. The three-story building itself is striking with its wrought-iron work and interior courtyard. The second and third floors are full of small art studios with a wide range of media. The coop is the only place in Provincetown where all the products are locally made. You will always find one of these wonderful artists there: Stan Elfbaum, Toni Levin, Bruce Lounsbery, Taffy McGann, Kathleen Masterson, Joanne Millbury, William Saggio and Stef Semple.

Retrace your steps back to MacMillan Wharf and walk to Provincetown Art Association & Museum at 480 Commercial Street. Don't miss this Museum, which recently received accreditation from the American Association of Museums (AAM), the highest national recognition for a museum. Accreditation signifies excellence to the museum community, to governments, funders, outside agencies, and to the museum-going public.

PROVINCETOWN ART GUIDE WITH FINE DINING

To get a comprehensive look at all the galleries in Provincetown, pick up the free "Provincetown Art Guide with fine dining" for the best of Provincetown's galleries, restaurants, antiques, artists, artisans, art services, theatre, art classes and calendar of exhibits. Books are available at galleries, inns, guesthouses, hotels, transportation centers, museums, bookstores, coffee shops, Chambers of Commerce and fine restaurants in Provincetown and in select locations across the Lower Cape. Or find it on the web and order your own guide at www.provincetownartguide.com.

PROVINCETOWN **ART GUIDE**
2005 EDITION
with fine dining

galleries . museums . theatres . schools . artists . artisans & more

PROVINCETOWN ART - 112
ASSOCIATION & MUSEUM

460 Commercial St., Provincetown – Year Round
October-Memorial Day
Thursday-Sunday, 12pm-5pm,
Memorial Day-September
Monday-Thursday, 11am-8pm
Friday 11am-10pm,
Saturday and Sunday 11am-5pm
also by appointment
508-487-1750 • www.paam.org

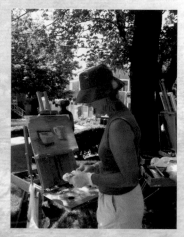

Hundreds of artists have called the Outer Cape home over the past century. The Provincetown Art Association and Museum has been integral to the community comprising the Provincetown Art Colony. It embodies the qualities that make Provincetown an enduring American center for the arts.

In 1914, a group of artists led by Charles Hawthorne, a prominent art teacher, established the art association, and in the 1920s, the association drew up a mission statement: to exhibit and collect art works of merit and to educate the public in the arts. That mission remains today. The newly renovated and expanded PAAM has long served as the central guiding force of this art colony on the tip of Cape Cod.

Welcoming nearly 50,000 visitors each year to more than one hundred annual programs, PAAM is a nationally recognized year round cultural institution that fuses the creative energy of America's oldest active art colony with the natural

beauty of outer Cape Cod that has inspired artists for generations. The new wing completed in late 2005 allows the museum to host international exhibitions and gives more space to art classes. As interest in the region's contribution to American art history continues to grow, PAAM presents an ever-changing lineup of exhibitions, lectures, classes, and cultural events that seek to promote and cultivate appreciate for all branches of fine arts. PAAM's permanent collection holds about 2500 contemporary and historical works of art from 600 different artists who have worked on the Outer Cape, such as Robert Motherwell, Hans Hofmann,

Edwin Dickinson, and Blanche Lazzell. Collection works are exhibited year-round in PAAM's five galleries along with works by contemporary artists within the PAAM membership—a growing community of more than 1,800 artists, collectors and enthusiasts.

Since the 1920s the association has participated in the Outer Cape tradition of offering classes in the arts. The year-round Museum School gives artists of all levels a chance to work with professional artists.

Three naturally lit studios provide an ideal space for accredited college level courses in the spring and fall, year round workshops for children and adults, and a new line up of art history classes utilizing the works from PAAM's permanent collection. The Museum School at PAAM works closely with local schools, fostering appreciation for the arts through free children's programming, interactive tours, and a free public lecture series. The association also hosts auctions, tours, workshops, lectures and demonstrations.

Campus Provincetown

CAMPUS PROVINCETOWN: Watercolors and wood-carving. Poetry and fashion illustration. Print-making and film-making. These are all classes available on the Outer Cape in a rich and vibrant consortium of more than 100 courses in the arts, sciences and the environment known as Campus Provincetown. Campus Provincetown was created by a group of community, arts, environment and business leaders who believe they can stimulate and strengthen the economic development of Provincetown and the greater community of the Outer Cape through the marketing of courses and programs. The courses are offered by local arts, education and science organizations. The project is considered so successful, some say it has created a historic Provincetown Renaissance. Among the participating organizations in Campus Provincetown are Cape Cod Community College, Center for Coastal Studies, Fine Arts Work Center, Lower Cape Cod Community Development Corporation, Pilgrim Monument and Museum, the Provincetown Art Association and Museum, Provincetown International Film Festival, Truro Center for the Arts at Castle Hill, and the Provincetown Public School System.

Continue down Commercial Street and take a left into the central parking at McMillan Wharf. It is easier to walk and enjoy Commercial Street and the center of Provincetown. Please note, if you cannot find parking for Provincetown Art Association & Museum, your best bet is to go to McMillan Wharf first. Leaving the parking lot, go down to Bradford and turn left. At Admirals Landing on the left, turn into Pearl Street. The Fine Arts Work Center is on your left.

FINE ARTS WORK CENTER - 113
24 Pearl Street Provincetown - Year Round
Monday-Friday, 9am-5pm
508-487-9960 • www.fawc.org

The Fine Arts Work Center is a key institution in Provincetown's long history as a haven for artists. In 1968, a group of eminent artists and writers recognized the need to support talented people at the beginning of their careers. Since that time, FAWC has provided housing and stipends to over 750 emerging artists from the United States and abroad, the largest program of its type in the country. Each year, ten writers and ten visual artists are offered a seven-month residency. Distinguished artists and writers visit FAWC throughout the year presenting readings and lectures to the public and working with the Fellows. In the Summer, FAWC offers classes in visual arts and creative writing. In addition, FAWC has an MFA program with Mass. College of Art. FAWC is located at the former Days' Lumber Yard, which was rented to artists as

studio space for decades before FAWC acquired it. The Hudson D. Walker Gallery is open to the public and hosts year-round exhibitions. Readings and lectures are offered in the evenings in the Stanley Kunitz Common Room.

MASSART AT THE FINE ARTS WORK CENTER

The Massachusetts College of Art has partnered with the Fine Arts Work Center to create a unique low-residency MFA program in Provincetown. Students travel to and reside in Provincetown for approximately two 3 ½ week periods per year. The remaining ten months are spent where students normally reside, working with individual mentors and enrolling in on line courses. Two features make this program unusual. First, it attracts artists working with two-dimensional media including painting, printmaking, drawing, and mixed media, and emphasizes studio production so

that art history and writing components support studio work. Second, it creates an intensive and optimal environment for artist to pursue their studio work and receive feedback from leading art professionals with national reputation. More information can be found at www.MassArt.edu

PILGRIM MONUMENT AND PROVINCETOWN MUSEUM

High Pole Hill, Provincetown
Daily 9am-5pm, April-November,
June, July, August until 7pm
Also open for the Annual Lighting of the
Monument, Thanksgiving eve
508-487-1310 • www.pilgrim-monument.org

The 252-foot-tall Pilgrim Monument, which commemorates the "first landing" of the Mayflower Pilgrims in Provincetown in 1620, is the tallest all-granite structure in the United States. President Theodore Roosevelt laid the cornerstone in 1907, and President William Howard Taft dedicated the completed monument in 1910. The museum's permanent exhibits focus on Provincetown's rich history–including the arrival of the Mayflower Pilgrims, the town's maritime history, the early days of modern American theater in Provincetown, and the building of the monument. It regularly mounts special exhibits, book signings, talks, panel discussions, walking tours, a house tour and children's programs.

MARITIME ARTS

Maritime art has a tradition going back hundreds of years, but on Cape Cod, Martha's Vineyard and Nantucket, with 560 miles of coastline, the influence of the sea is deeply ingrained in the hearts of many of the region's artists. Galleries and artists throughout the region regularly display maritime paintings, including Paul Galschneider Studio on Nantucket, Winstanley-Roark Fine Arts in Dennis, and Cahoon Museum of American Art in Cotuit. Other artists influenced by the maritime heritage are Ron Geering in Woods Hole, who uses fantasy images and lines from sea shanties on his pottery, and photographer Louisa Gould on Martha's Vineyard, who has produced the photography book, Wooden Boats of Martha's Vineyard, in addition to her famous yachting images.

Reminders of the Cape's maritime heritage are everywhere, in Provincetown's Library, with the half scale model of the schooner, Rose Dorothea, and the Pilgrim Monument in Provincetown. Sailors on ships developed scrimshaw and basket-weaving to help pass the time, and impressive displays are on Nantucket, a great day trip, at the Whaling and Lightship Basket Museums.

The entire Cape celebrates its maritime history and traditions during May, with Cape Cod Maritime Days (www.capecodmaritimedays.com) featuring lighthouse and walking tours, maritime art exhibits, boat-building demonstrations, kayaking excursions, and village festivals. Museums on Nantucket specialize in telling the story of the region's maritime history, including the Shipwreck and Lifesaving Museum and the Egan Maritime Institute. On the Cape are the Cape Cod Maritime Museum in Hyannis, the Old Harbor Lifesaving Station in Provincetown, the Small Boat Museum in Woods Hole and the Osterville Museum on West Bay Road in Osterville.

*F*og often envelops the Island of Nantucket, wrapping the island in a protective embrace and causing natives to refer to it affectionately as the Grey Lady. But when the sun cuts through the fog, the island is bathed in a stark, atmospheric light beloved by the many artists that call the island home.

Artists have been attracted to this idyllic island, 30 miles off Cape Cod's southern coast, for more than 100 years. The island's art scene heated up in the 1920s when artists filled the studios along Old South Wharf and could be seen at their easels all around the island.

Nantucket's cobble-stoned streets, bustling harbor, and windswept moors are nothing if not picturesque, and many of the island's artists capture these

landscapes in oils, watercolors and pastels. In addition, there are several crafts, including Nantucket Lightship Baskets, scrimshaw, weaving, and sailor's valentines, that have strong ties to the island and are still practiced today. This community of artists and crafters contributes to the richness of Nantucket's cultural scene. Though the island is relatively small, only 14 miles long and 3 ½ miles wide, with about 10,000 year-round residents, there is no shortage of activities, from art openings and theater to museums and concerts. Festivals are held throughout the year, including the

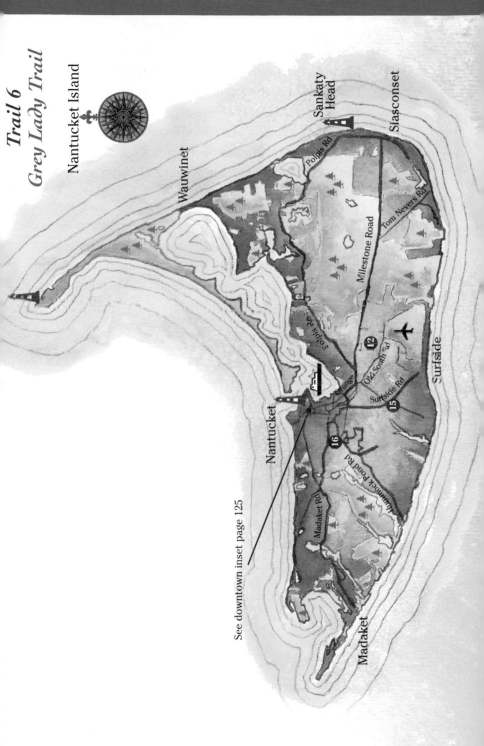

Trail 6
Grey Lady Trail

Nantucket Island

Wauwinet

Sankaty Head

Siasconset

Polpis Rd

Tom Nevers Rd

Milestone Road

Polpis Rd

12

Surfside Rd

Old South Rd

Orange

15

Surfside

16

Nantucket

See downtown inset page 125

Madaket Rd

Hummock Pond Rd

Madaket

Nantucket Daffodil Festival in April, the Nantucket Wine Festival in May, the Nantucket Film Festival in June, as well as the Nantucket Arts Festival in October and Christmas Stroll in December. The island's colorful history from Quakers to whalers has been carefully preserved in exhibits at the impressive Whaling Museum and a number of other fine historic sites.

An equally intriguing part of the island's history is captured along the Black Heritage Trail, which explores the history of the African Americans who first came to Nantucket in the 17th century and established a thriving community on the island.

How To Use This Trail

If you are here for one day or are coming into town from the beaches, we've outlined a walk with 8 stops in the core downtown area within ten blocks of the ferries. Then, rather than giving individual directions for those just outside this area, we've given you directions from a point along Main Street—whether heading out towards Madaket or Mid-Island. There are wonderful working studios and also a gem of a museum that are merely a pleasant 15-minute stroll from Main Street. Take as many strolls as you need, but don't plan on driving to the in-town studios. The one-way streets will take all the joy out of it. For those here for more than a day, the last group of galleries and studios is spread throughout the island. You need to either hop on your bike, get in a car, or check the seasonal public shuttle maps. We've set these studios up along a driving trail, but we've also placed them on the Island and town maps so you can visit them from any point. Most of the Nantucket artists live on the island year-round. Those who indicate they

are open by appointment are happy to show their works to visitors off-season. If you have any questions or need further guidance, just visit the Nantucket Island Chamber of Commerce office at Zero Main Street. They helped form this trail, have visited the spots, and know what might work best for you.

Downtown Nantucket

Grey Lady Trail

This trail starts at Old South Wharf by Nantucket Harbor. Old South Wharf is on the far side of the Boat Basin, with galleries in two rows of the Old South Wharf shacks, opening on both sides. Eric Holch's gallery is located in Shanty #10, and the Scrimshander Gallery is at #19.

ERIC HOLCH GALLERY - 1
10 Old South Wharf - Year Round
Daily, June 15-September 15
June and September, 11am-4pm,
July-August 10am-6pm.
Other times by appointment.
508-228-7654 • www.ericholch.com

As a child, Eric Holch's summers were spent on Nantucket, and he finds those familiar harbors, side streets, sandy beaches, and architecture a constant fascination in his artwork. Eric creates limited edition serigraph prints, silkscreens, and oil paintings with a crisp, colorful, graphic style. The primary colors in his palette are the stuff of happy memories.
The gallery's small space is full of finds; prints are everywhere, even on the ceiling. The gallery also sells Eric's nautically-inspired silk neckties and bowties, as well as cards and posters.

OLD SOUTH WHARF is alive on Friday and Saturday nights, with many opening receptions at area galleries, and a great place to stop for lunch or dinner, too. In season, Eric, pictured here, and other artists are joined by Karen Ganga Sheppard, who brings her beautiful weavings to Number 15.

A few doors away on the same side of the wharf is the Scrimshander Gallery.

THE SCRIMSHANDER GALLERY - 1
19 Old South Wharf - Year Round
April 15-October 31, daily 11am-5pm
Other times by appointment
508-228-1004 • www.scrimshandergallery.com

Using a large magnifying glass, Michael Vienneau etches delicate lines into ivory, creating elaborate tableaus like three-masted schooners lined up in historic harbors. Michael was raised in Duxbury, where he started carving as a teenager. He moved to Nantucket in 1974, and has been a scrimshander ever since. Michael excels at a style of scrimshaw that was born during the golden age of whaling in the 18th century. All his work is hand-carved on antique whale's teeth, fossil walrus, wooly mammoth and mastadon ivory that is between 100 and 20,000 years old. Visitors who stop into his gallery will find him at work beneath a whale jawbone that hangs from the ceiling creating both traditional and contemporary works. Carving on a new giant jawbone each year fills his winter on the Island.

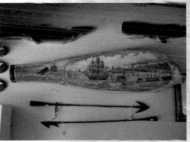

Head into town from the wharf. Go past the grocery store through the parking lot. At the end of the lot turn left onto Candle Street. The next artist has his downtown studio/gallery here (just on the right), sharing the space with a wonderful portrait painter.

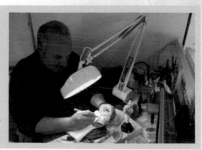

SCRIMSHAW: Sailors aboard whaling vessels began crafting scrimshaw to fill the time during long hours at sea. In the spirit of using every part of the great whales, they crafted intricate and painstaking carvings and engraved images on whale teeth and bone. Today the craft is still practiced on Nantucket, where several scrimshanders still make their home. In addition to the traditional but dwindling supply of antique ivory and bone, scrimshaw is now also done on fossil ivories from Alaska and Siberia.

PAUL GALSCHNEIDER
DOWNTOWN STUDIO-GALLERY - 2
1 Candle Street
Daily 10am-6pm, May-October
Other times by appointment
508-228-2658 • www.paulgal.com

Paul Galschneider is an impressionist plein air oil painter, best known for his colorful seascapes, bold florals, and dark-hued interiors. Originally from Czechoslovakia, Paul has made Nantucket Island his home. His downtown location is centrally located for you to view his work. To see him at work go to his studio on Atlantic Avenue. (p.135)

MARION P. SHARPE STUDIO - 2
1 Candle Street
mid-June-mid-October, 10am-1pm, 3pm-5pm
Call to arrange sittings
508-228-4086

Working in pastels or oils, portrait painter Marion Sharpe captures her subjects beautifully. Marion is well-known for creating exceptional likenesses that become heirlooms for families. Formerly of Portraits Inc., Marion has taught at a number of private high schools, colleges and museum art classes. She works on commission with individual and family portraits. From mid-June to mid-October, visitors can watch Marion work through the large window of her studio at One Candle Street, near Nantucket Harbor. In the winter, the studio serves as gallery for fellow artist Paul Galschneider.

Turn right out of gallery. At the intersection of Candle and Washington you'll see the Artists Association of Nantucket Gallery straight ahead, just past the flagpole.

ARTISTS ASSOCIATION OF NANTUCKET - 3
JOYCE AND SEWARD JOHNSON GALLERY
19 Washington Street, Nantucket - Year Round
April 7-December 31, Daily, 10am-6pm
January 1-April, Friday-Sunday, 11am-5pm
508-228-0294 • www.nantucketarts.org

The Joyce and Seward Johnson Gallery features paintings, sculpture, photography, jewelry, drawings and mixed media by established island artists and emerging local talent. The more than two hundred artist members who exhibit in the gallery are residents of Nantucket whose work has been selected by a review committee of peers. The gallery hosts a year-round schedule of changing member exhibitions, featured artist shows, juried shows, auctions, fundraisers, and community-oriented arts events. It has rotating exhibitions of more than two hundred pieces of art at any given time, with a price-point that is affordable for any art lover.

Heading out the door, take a right onto Washington Street. Walk with the harbor on your left, and you can stop at the pocket park just past the town pier. Continue along Washington until it intersects with Francis. Take a right onto Francis and go to the end, where it intersects with Union. The Lightship Basket Museum is right in front of you in a beautiful old house, set back through an 1820 garden.

NANTUCKET BASKETS: The Nantucket Lightship Basket is a unique art form born on the island with a tradition that continues today. Nantucketers, confined for months at a time aboard off-shore lightships, crafted this new basket form inspired by local coopers who made thousands of wooden barrels for the whaling industry. The key elements of these sturdy baskets are the use of rattan and staves in a tight weaving process, their solid wooden bottoms, often hand-turned, wooden molds used to shape them, and rims which are secured by nails. In the 1950s, Jose Formoso Reyes added a lid to the basket and called them "Friendship Baskets," giving birth to the Nantucket Basket purse which is still popular today.

NANTUCKET LIGHTSHIP - 4
BASKET MUSEUM
49 Union Street
Memorial Day-Columbus Day,
Tuesday-Saturday, 10am-4pm,
Closed Sunday & Monday
Admission $4 for adults,
$2 for children under 12 and seniors,
free to members
508-228-1177
www.nantucketlightshipbasketmuseum.org

This little gem of a museum just a short walk from Main Street is dedicated to preserving the tradition of Nantucket Lightship Baskets, the tightly-woven vessels made during the long, lonely hours by those serving duty on lightships, which were off-shore lighthouses. The most famous was the South Shoal Lightship, located about 25 miles south of Nantucket in an area notorious for shipwrecks. It was aboard those lightships in the mid 19th century that this specific form of basketmaking emerged as a cottage industry for the Nantucket crewmen. Visitors to the museum walk through an "1820 garden," with antique roses, lavenders, and apple trees, before entering into the restored 1820 working class home. The Museum houses the actual workshop of well-known basketmaker Jose Formoso Reyes (1902-1980). Within the gallery are many different styles of Lightship baskets, both historic and contemporary, from the museum's permanent collection and on loan from collectors. The museum also offers weaving demonstrations and lectures by basket makers, historians, scrimshanders, and restoration experts.

Heading out the entrance, turn right and take an immediate left onto Weymouth, which connects Union and Orange. Make a left onto Orange, and the Weaving Room is almost immediately on your right. On a sunny day look for the beautiful rugs framing the open doors of The Weaving Room between E. Dover and Weymouth.

THE WEAVING ROOM - 5
73 Orange Street, Nantucket - Year Round
Monday-Saturday, 9am-3pm
Other times by appointment
508-228-9047 • www.nantucketweavingroom.com

The deep blues and greens of the waters surrounding Nantucket are the inspiration for the works of Swedish-born weaver Anna Lynn Bender. Anna, who studied weaving at a Swedish tapestry workshop, came to the United States in 1980. She weaves rugs, tapestries, pillows and one-of-a-kind clothing at the ten-foot loom in her studio. Her hand-woven works begin with a watercolor image, which often comes about from experimentation. She then translates that image into a textile design. Threads and yarns are mixed as on a painter's palette.

Leaving the Weaving Room, take a left onto Orange and head back towards Main Street. Along Orange, you'll see beautiful historic buildings that were once whaling captains' homes. If architecture is your thing, pick up a self guided architectural walking tour brochure from the Nantucket Island Chamber of Commerce.

As you approach Main Street, looking across the street and diagonally to the left, you'll see the beginning of Centre Street. Walk this street to the intersection of Centre and Broad, with the Jared Coffin House right in front of you. Bearing left, to get to the shop of Charles Manghis, walk into Nina Hellman Antiques. The small space in the rear is Charles' workshop and studio/gallery. (Next page)

WALKING TOURS: Walking is a great way to discover Nantucket, and there are a variety of guided walking tours available for your enjoyment. Their themes vary, and include birding, wildflowers, marine ecology, geology, general history, literature, women of Nantucket, architecture, notorious Nantucketers, and even a ghost walk. Consult the Nantucket Island Chamber of Commerce's guidebook or web site for a complete listing of walking tours.

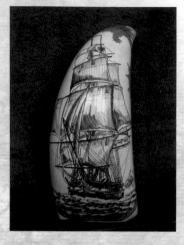

CHARLES A. MANGHIS - 6
SCRIMSHANDER/CARVER
48 Centre Street - Year Round
June-August, Daily, 10am-10pm
September-December,
Friday-Saturday, 10am-5pm
January-February by appointment
508-325-8815 • www.nantucketscrimshander.com

One of only a few scrimshanders on Nantucket, Charles Manghis has been an accomplished ivory carver for more than 35 years. Charles began working with ivory when he was 14 years old. Growing up in West Barnstable, on Cape Cod, he was always fascinated by the history of the area, and for him, scrimshaw is the perfect melding of history and art. His knowledge of the whaling era is evident in his detailed carvings that capture that colorful time. He sees scrimshaw as an original American Folk Art form, one of the few that doesn't trace its history to either Native Americans or Europeans.

Continuing out of town, at the corner of Broad and Centre, take a left onto Gay Street. At the top of Gay is the Academy Hill Apartment building. Walking through the parking lot to the left, over the hill and down the stairs, you'll come upon Gerry Scheide's Studio on the left, which is separate from her house.

GERRY SCHEIDE STUDIO - 7
11A Lily Street
Fridays and Saturdays, 10am-12pm, 2-4pm
Other times by appointment
508-228-9814 • ntktartist@aol.com

In a small studio cottage set behind her house, Gerry Scheide paints "primitive art," whimsical images on wood, canvas, and glass. Her work is a charming mix of colorful, fanciful scenes, featuring mermaids, whales and other nautical images that capture the spirit of Nantucket. She paints in oils on a variety of surfaces: barrel staves, antique buggy seats, quarterboards, and shutters. The sparkle in Gerry's eye comes through in the sense of humor in her work. One example: an enterprising group of mermaids offering whale rides to summer visitors!

Follow the path again to Gay Street, wander down to Broad Street and head toward the water. The Nantucket Whaling Museum is a block and a half down Broad on the left as you head towards Nantucket Harbor.

NANTUCKET WHALING MUSEUM - 8

13 Broad Street - Year Round
Mid-Feb.-mid-April,
Saturday & Sunday, 11am-4pm
Mid-April-mid-May,
Thursday-Monday, 11am-4pm
Mid-May- October 31,
Sunday-Saturday, 10am- 5pm
July & August, 1st & 3rd Wednesdays,
10am-8pm
November 1-mid-December,
Thursday-Monday, 11am-4pm
Closed on Easter, Thanksgiving,
Christmas, and New Years Day,
508-228-1894• www.nha.org

Founded in 1894, the Nantucket Historical Association (NHA) owns twenty-two historic buildings and sites. With part of their mission to preserve and interpret these exceptional properties; they strive to make their buildings accessible to island residents and visitors alike. The jewel in the crown is the Whaling Museum in the heart of town. Featuring a fully restored 1847 spermaceti candle factory that houses the original whale-oil beam press–a three-story wooden structure that is the only such artifact still in its original location anywhere in the world–the museum also has a fully rigged whale boat, and a forty-six-foot sperm whale skeleton. This is especially impressive as the sperm whale made Nantucket the most prosperous port in America during the late eighteenth and early nineteenth centuries. Other galleries display major changing exhibitions, world-class scrimshaw, Nantucket Lightship baskets, and numerous historic objects and paintings. They also have wonderful activities for children.

This ends the walking tour of the downtown area. Whether you wish to continue by foot or car, the directions we are providing are driving directions from the center of town. If you are a hearty walker or using your bike, the first three stops are easily accessible from town. Off the top of Main Street, take Pleasant Street to Mill Street to get to the 1800 House. If you want to continue another two blocks up Pleasant Street and take a right onto South Mill Street, you can see the Old Mill.

1800 HOUSE - 9
4 Mill Street
508-228-1894, x 128
Open for classes
www.nha.org/1800house

Traditional crafts are alive and well at the Nantucket Historical Association's 1800 House. In 2005, the NHA began using the restored 1800 House as a venue for a new program of teaching many of the Early-American Arts & Crafts that played an important part in island history. Each course is designed to utilize the knowledge and craftsmanship of experienced artisans-many from Nantucket and several who travel to the island. This year, several instructors have taken inspiration from the NHA's comprehensive collection of eighteenth-and nineteenth-century artifacts; some of the classes include making Black-Ash Baskets, Painted Floor Cloths, Sailors Valentines, Chair Caning, Reverse Painting on Glass, Early-American Embroidery, Folk Art Painting on Tin, Wood Carving, and Pierced Lampshades. All classes are geared towards adults.

Continuing out of town on Pleasant Street bearing right onto Atlantic Avenue, #14 will be on your left. Pull into the cobblestone driveway and walk through the winding garden path lined with stone sculptures.

ATHENEUM: The Nantucket Atheneum on India Street is one of the oldest libraries in continuous service in the country. In this elegant and historic Greek Revival Building (1847) are wonderful collections of historic paintings, sculpture, ship models, and scrimshaw. Major 19th century literary, political, and cultural figures — including Ralph Waldo Emerson, Henry David Thoreau, and Frederick Douglass — lectured in the Great Hall, which also houses special collections on Nantucket history, genealogy, and the life and arts of 19th century America.

PAUL GALSCHNEIDER STUDIO - 10
14 Atlantic Ave - Year Round
9am-11am Monday-Friday
Other times By appointment
508-228-2658 • www.paulgal.com

Paul Galschneider is an impressionist, plein air, oil painter. His Art Studio, located behind his home, reflects the man behind the painting. There you can get a perspective on his life and interests. The artists personality is demonstrated in the design of his studio and gardens, with winding pathways, and unusual decorum. Best known for his colorful seascapes, bold florals, and dark-hued interiors, his studio is an opportunity to see where he creates many of his works. You can also see his work downtown at 1 Candle Street. (2)

To reach the Artists Association's Office and Workshop space, take a right out of the driveway, back tracking one block, and take a hard right onto Pleasant. The Artists Association will be on your right.

ARTISTS ASSOCIATION OF NANTUCKET - 11
Workshop & Administration Office:
1 Gardner Perry Lane, 10am-3pm
508-228-0722 • www.nantucketarts.org

The Artists Association of Nantucket, formed in 1945, is dedicated to fostering the growth of the visual arts on Nantucket. Started by local artists and craftspeople, there are now almost 600 members. In addition to the gallery on Washington, there is a library, arts education program, and the island's largest permanent collection of 20th century Nantucket art. Throughout the year there are classes and workshops for adults and children in this building. These include, painting watercolor, stone carving, clay building, and life drawing. Call or go to website for class schedules.

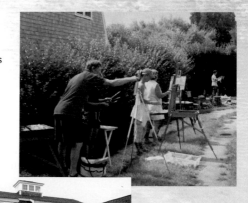

Driving directions - *Leaving the Artists Association, take a right back onto Pleasant, and follow it until you get to a traffic circle. Go halfway around, and continue straight (the third right) onto Sparks Avenue. At the stop sign, which is at a rotary, take a right onto Old South Road. Go over a mile until you see Egan Lane, and take a left. Tim Parsons house is just down the road. #80 is written on the rock. To reach his studio, walk down the steps behind the house into the workshop. His shop is also reachable on the Old South Loop Shuttle, Egan and Old South Road stop.*

NANTUCKET LIGHTSHIP BASKET SHOP (12 - ISLAND MAP)
80 Old South Road - Year Round
May-December, Monday-Friday,
10am-12pm, 1-4pm
January-April, 1pm-4pm
Closed holidays
508-228-8714 • www.nantucketbaskets.com

Timothy Parsons believes there is actually no "traditional" Nantucket Lightship Basket. Artisans have always experimented with different shapes and weaves. Incorporating traditional basket-making techniques and designs with his own creativity, Timothy creates fine examples of the craft. He starts with the traditional elements: the mold, the weaving cane, the staves, the rims. He also creates carvings for the baskets, usually in ivory or ebony. A small display case in the front contains scrimshaw-carved items for the baskets. On the walls hang all the basket-making equipment.

AFRICAN MEETING HOUSE:The African Meeting House at 29 York Street is a vivid reminder of Nantucket's thriving nineteenth-century African American community. Erected in the 1820s by the African Baptist Society (of which whaling Captain Absalom Boston was a trustee), it is the only public building still in existence that was constructed and occupied by the island's African Americans during the nineteenth century. The small post-and-beam building dates from about 1827, when it was a church, a school for African children, and a meeting house. For more information, go to www.afroammuseum.org

Return to Old South Road and take a right, backtracking to the rotary. Take the third right back onto Sparks Avenue and go to the traffic circle. At the circle, take your third right onto Hooper Farm Road. Island Weaves is on your left, at #44, and the driveway is at the rock. In season, take the NRTA Island Shuttle on the Mid Island loop to the Brinda Lane stop.

ISLAND WEAVES - 13

44 Hooper Farm Road - Year Round
Also in summer : 15 Old South Warf
Monday-Friday, 10am-1pm and 2am-4pm
Closed holidays and last week of October
508-825-9771 • www.islandweaves.com

Growing up on Nantucket, Karin Ganga Sheppard was fascinated as a young girl by the weavers at Nantucket Looms and the beautiful fabrics they created. After college, she worked there for 20 years, learning the craft from master weavers At Island Weaves, she crafts her own designs from high-quality natural fibers, like silk, alpaca, rabbit-hair angora, and cashmere. She uses her three looms to create a wide variety of products: throws, shawls, scarves, upholstery yardage, rugs, even dishtowels. Her Madaket Mall Mats, which take their name from the nickname for the Nantucket dump, are woven from recycled towels, jeans, and old wool blankets.

Take a right onto Hooper Farm Road, a left onto First Way and drive to the end, going through the school parking lot. Take a right onto Surfside Road and first left onto Vesper Lane. Take the second left (Polliwog Pond Road). # 5 is on your right.(next page)

(next page)

CONSERVATION: Nearly 50% of Nantucket's approximate 30,000 acres is preserved as open space by a handful of dedicated conservation organizations that welcome the public onto a majority of it. The Nantucket Conservation Foundation, founded in 1963, owns 8,700 acres – 29 % of the island. The Nantucket Islands Land Bank, the first of its kind in the U.S., levies a 2% tax on real estate transactions to fund land purchases. These and other groups work cohesively to protect Nantucket's open spaces and to educate the public.

PETER FINCH, BASKETMAKER - 14
5 Polliwog Pond Road
June-September Monday-Friday 9am-5pm
Other times by chance or call for an appointment
508-228-2267 • www.nantucketbasketmaker.com

Weaving Nantucket Lightship baskets is a craft that goes back more than a hundred years on the island. Peter Finch makes his baskets in the time-honored tradition, working in the same style of the great basketmakers Reyes, Gibbs, and Boyer. But Peter is not the subdued person you might think of when you think, "basketmaker."

A bundle of energy, he is lively and engaging. Peter's working studio and teaching room are attached to his house on Polliwog Pond; it's just a step off the beaten path, but worth the trip. Visitors enter through the porch on the left, where supplies are gathered. Peter also teaches basket weaving, and students come and go from the studio.

Continue right out of his driveway, go straight across the intersection, as Polliwog turns into Roberts Lane, Herr Looms will be on the left on Roberts Lane. The door to the studio is at the back of the studio building.

HERRLOOMS (15 - ISLAND MAP)
19 Roberts Lane
September-May Tuesday, Wednesday, Thursday
9am-12:30pm
Daily June-August 1pm-3pm
All other times by appointment
508-325-4561 www.herrlooms.com

When Allison Herr was five years old, her grandmother taught her how to knit. "You are the boss of these needles," her grandmother said. That early training taught Allison to be undaunted by knots and dropped stitches. She went on to learn crochet and embroidery, but none of those fiber arts satisfied her desire to combine different colors and textures. She finally discovered loom weaving. From shiny and elegant silks for scarves to coarse and earthy wools for rugs, she now finds uses for all the fibers and colors she loves.

Continue along Roberts Lane, turning right onto Somerset Road. Cross Vesper Lane onto Joy, passing cemeteries on both sides. Turn left onto Mount Vernon. At the stop sign, turn right and take an immediate left onto Quaker Road. Turn left onto Madaket Road and Custom Woven Rugs will be on your right. Look for an oversized mailbox, #19. In season, take the shuttle to the Madaket Road stop.

CUSTOM WOVEN RUGS
(16 - ISLAND MAP)
19 Madaket - **Year Round**
Daily, 8am-5pm
508-228-4873 • **www.nantucketweaver.com**

Hillary Anapol has been weaving for more than 20 years in wool, cotton, and linen, starting as a 14-year-old. Having summered with her family on Nantucket as a child, she decided to make her home on the island after college. The studio is a short walk from town and has six looms which are often laden with various projects in process. The shelves are stocked full of samples, custom-colored and in various stitches and textures. There are both contemporary and traditional period rugs, in designs from doublewoven checked, to traditional twill and tabby stitches. All therugs are custom colored, sized, and reversible.

SHEEP: Early settlers took advantage of the island's lack of predators and finite wilderness to raise sheep. Sheep raising, spinning, and weaving became major occupations. In the 1800s, the intense fog of late June and early July were called sheep storms, drenching the thick coats of sheep grazing in the moors. They knew that next was the beginning of the hot, sunny days which would dry the coats and signal the time for the famous sheep-shearing festivals. A mondern day version happens every fall.

Nantucket Festivals & Chamber Events

ANNUAL DAFFODIL FESTIVAL WEEKEND – APRIL

Nantucket's traditional welcome to spring with over three million daffodils blanketing the island. Events include the Antique Car Parade and Tailgate Picnic, Flower Show, historical walking tours, art exhibits, bird watching and more.

HISTORIC PRESERVATION MONTH – MAY

Nantucket celebrates local history, heritage, education, and historic preservation efforts with a month of activities. Organized by the Nantucket Preservation Trust.

THE NANTUCKET WINE FESTIVAL – MAY

A multi-faceted exploration of food and wine emphasizing Nantucket's historic celebration of all things gastronomic. Nantucket Island becomes host to over 100 wineries of international acclaim.

THE NANTUCKET FILM FESTIVAL – JUNE

Dedicated to screenwriters, the Nantucket Film Festival is a premiere event showcasing independent films, panels, readings, and the annual screenwriters tribute.

ANNUAL SANDCASTLE & SCULPTURE DAY – AUGUST

Islanders and visitors create masterpiece sandcastles and sand sculptures on Jetties Beach.

THE NANTUCKET ARTS FESTIVAL –EARLY FALL

A week-long celebration of the cultural arts on Nantucket, featuring theatre, music, dance, visual arts and literary events. Venues throughout the town.

FALL ON NANTUCKET – OCTOBER – NOVEMBER

Celebrate the relaxed pace of Fall on Nantucket with a wide variety of fall events such as a Cranberry Harvest Festival, Harvest Festival, the annual Chowder Contest in mid-October, and the Fall Restaurant Week.

ANNUAL CHRISTMAS STROLL WEEKEND – DECEMBER

An old-fashioned holiday celebration with over 150 decorated Christmas trees, Victorian carolers, bell-ringers, theatrical productions, craft shows, house tour, antique auction, concerts, art exhibitions, and much, much more. Christmas Stroll is part of the month-long Nantucket Noel celebration from Thanksgiving through New Year's.

For the most updated listing and exact dates, go to www.nantucketchamber.org

ℐETTING SAIL

All travelers have their favorite spots, and our region gives you three unique destinations. Two are islands and getting to them sets you in the mood for new adventures–from the romantic to the fun filled. Whether you're a fan of Moby Dick or Jaws, a trip from Cape Cod onto Nantucket or Martha's Vineyard takes you to places that seem far away. You might think you've traveled back in time, except that modern day luxuries and amenities are found wrapped in elegant 18th and 19th-century packages.

Setting sail on the ferries, or flying over the sound, you will experience regions that are preserved with conservation land–as well as towns that are quite lively during the season, and off season offer a tranquility valued by all its residents. But they are willing to share. Come and collect treasured memories of carefree days with your children, romantic times with your partner, or just reconnect with your inner self. From the one town on Nantucket to the variety of villages on Martha's Vineyard, you'll find quaint inns, interesting historic sites and pristine beaches. Each island has its favorite place to watch the sunset. And the rolling moors, heaths and cranberry bogs are as romantic as you can find. You can explore for a day, but you'll want to plan a longer trip to truly experience a time away.

In the legends of the
Aquinnah Wampanoag, the
Native American tribe of
Martha's Vineyard,
Moshup, a benevolent
being, is responsible for
the shape of the island.
From the Aquinnah cliffs, a
sacred place for the tribe, to the tip of Chappaquiddick,
the island has many wonderful places to discover.
Explorer Bartholomew Gosnold must have felt the same
way after he landed on the island in 1602 and named the
island after his daughter, Martha, and the many
grapevines he saw. Today's explorers may find that
travelling to Martha's Vineyard is like a trip to a more
innocent time. There's a feeling of small town
community in this place where neighbors swap stories
at the farmers market in West Tisbury, sheep graze on
rolling pastures overlooking the ocean, and the cliffs of
Aquinnah glow red at sunset.

There is rich culture and history in the island's six
towns. Vineyard Haven, the Island's main arrival port,

boasts shops and galleries up
and down Main Street. In Oak
Bluffs, you will find a
neighborhood of Victorian
gingerbread cottages, while
Edgartown is a museum-piece
community, a seaport village
preserved from the early 19th
century. The up-island towns
of Chilmark and West Tisbury have winding roads
leading through the rolling hills and past unmatched

Trail 8
Moshup's Trail
Martha's Vineyard

Oak Bluffs

Vineyard Haven

Edgartown

Katama

Edgartown - Vineyard Haven Rd

County Rd

Wing Rd

Main St

Franklin Ave

Tisbury

Barnes Rd

West Tisbury

Edgartown - West Tisbury Rd

West Tisbury

Old County Rd

State Rd

North Tisbury

South Rd

North Rd

Middle Rd

Chilmark

Nashaquitsa

Menemsha

State Rd

Aquinnah

coastline. Majestic Aquinnah on the far west side of the island is the ancestral home of the Wampanoag tribe. Many visitors to Martha's Vineyard only see the ferry port towns of Edgartown, Oak Bluffs and Vineyard Haven. Following this trail will lead you all over the island. It will take you along winding roads, and past woods, farms and many stone walls. It will lead you to discoveries you never imagined. That's how it should be. Exploring this unique island, shaped by Moshup, is just part of the adventure.

How To Use This Trail

We've created a trail that starts in Vineyard Haven on Main Street, and then takes you driving or biking around via Oak Bluffs. One place to stop for a longer stay is the Featherstone Center for the Arts, in a bucolic setting perfect for picnicking. Schedule your day trips around the Vineyard Artisans Festival dates to see a wide range of Island based artists and artisans; taking the shuttle or taxi to get to the Grange or Ag Hall. Mix your touring, shopping, and dining on the main streets of Edgartown while visiting the Old Sculpin Gallery. But don't miss the individual artist studios and galleries listed, because those artists are more than happy to talk to you about how they create their work and what inspires them. You can drive the entire trail the way it's written, or get a map and give yourself a few days to enjoy visiting the various stops

*This trail begins in downtown Vineyard Haven. If you
are arriving by boat, walk into town to Main Street
and the Louisa Gould Gallery is between Norton Lane
and Union Street, at 54 Main Street.*

LOUISA GOULD GALLERY - 1
54 Main Street Vineyard Haven - Year Round
April 1-October 31, 11am-5pm,
Sundays 12pm-5pm
Other times by appointment
508-693-7373 • www.louisagould.com

Known for her yachting photography, Louisa
Gould began her gallery to show contemporary
photography with a strong marine theme. She has
expanded this to include a diverse range of local,
regional, and emerging artists using various
mediums: oil paintings, works on paper, sculpture
and new media art. The Main Street gallery has
weekly events during the summer months including
artist receptions and gallery talks. Ms. Gould's
photography ranges from colorful moving yachting
images to serene black & white island landscapes,
sepia historic timepieces and exotic destination
wonders from around the world. In addition Louisa
has created new Photo-Impressionist Paintings
based from her photographs and is constantly
working with new mediums.

*If you parked in town, turn right down Union Street
and right on Water Street. At Five Corners, make a
sharp left at the stop sign and go down Beach Road
extension. The next gallery is at #13, on the
second floor above the Tropical Restaurant.*

WAMPUM: refers to the quahog clam
shell, which was used as a medium of
currency by the Wampanoag Indians,
natives of Cape Cod, Martha's Vineyard
and Nantucket. It was used in ceremoni-
al exchanges, as well as a symbol of
wealth, power, and prestige. Possession
of wampum was also believed to
have deep spiritual significance. In the writings of the early
1700s, wampum mostly referred to cylindrical beads, but
later, the term came to be attached to forms
of shell adornments, like cut slab shapes used in jewelry and
hair accessories.

VINEYARD SKY BEAD DESIGN - 2
13 Beach Street Ext., Vineyard Haven - Year Round
July-August,
Monday, Friday, and Saturday 10am-4pm
(Tuesday, Wednesday and Thursday at island shows.)
September through June, Monday though Saturday
10am-3pm
Closed Memorial Day, July 4th, Labor Day
508-939-0253 • www.vineyardsky.com

Sarah Young's jewelry business began with a passion for beading. Inspired by the endless variety of materials found throughout the world, her style delights the eye with color and texture, intricacy of detail and balance of composition. She uses flameworked glass, semi-precious stones, vintage European glass, Austrian crystal, freshwater pearls, furnace-blown glass, shell-filled beads, Czech and Japanese seed beads, and Turkish and Balinese silver. She often changes materials with the season, creating one of a kind and limited series pieces. Sarah will also work with a customer's fabrics or requests to customize jewelry.

We are now taking you to Oak Bluffs. Take a sharp left out of Beach Road Extension and head towards Oak Bluffs. You'll be on Eastville Avenue and the water will be on your left. Continue past the hospital, following signs to Oak Bluffs Center, and take a right onto County Road. Take a left onto Vineyard Avenue, passing the signs to the library. Travel less than a mile to Lucinda's Enamels. Look for number 11 on the left, which is noted on the white door of the arbor between the tall hedges. At the end of the hedge turn left into the parking area to the studio for Lucinda Enamels. And, if you have time, you can wander down the block to other galleries in the Arts District of Oak Bluffs on Dukes County Road, making this a great stop on your tour.

LUCINDA ENAMELS - 3
11 Vineyard Ave, Oak Bluffs - Year Round
March to October, 1pm-4pm, all days except
Thursdays and Sundays when the Artisans
Festivals take place; Closed holidays.
November-April, by appointment
508-696-7863 • www.lucindasheldon.com

Lucinda Sheldon says being an enamelist is like being an alchemist: the beauty comes out of the fire. Dating back to the 13th century B.C., enameling is an ancient art that uses ground glass colored with metal oxides. Lucinda does three different types of enameling: two ancient forms, cloisonné and champleve, and one modern form that she calls jeweled enamels. Inspired by her mother, Beryl Sheldon, who was an enamelist in the 1950s, Lucinda combines fire-polished crystal beads and vintage glass cabochon stones to make one-of-a-kind, vibrantly colorful pieces. Her dragonflies are particularly dramatic.

Where Vineyard Avenue and Dukes County Road meet, turn right. Make a right at the stop sign onto Wing Road. This becomes Barnes Road. Youll see signs to the airport. Stay on Barnes, for about 2 miles passing the lagoon on your right. You'll see a sign on the left for Featherstone Center for the Arts. Featherstone is accessible by bike (near Four corners), and by the Martha's Vineyard transit in season, the number 7 or 9 from Oak Bluffs or the airport.

FARMS AND STONE WALLS: Ancient stone walls line this artisans trail through the Vineyard, especially in the town of Chilmark, and a flock of sheep from Allen Farm can often be seen grazing on a bluff between the ivy-covered walls and the azure ocean beyond. Allen Farm is just one of many picturesque farms on Cape Cod, Martha's Vineyard and Nantucket. Many provide pick-your-own services in the summer or harvest festivals in the fall. Allen Farm has a shop where visitors can buy woolen clothing and fresh lamb meat.

FEATHERSTONE CENTER FOR THE ARTS - 4
30 Featherstone Lane off Barnes Road, Oak Bluffs
Year Round
Gallery Hours: Daily, 12pm-4pm
July and August, Flea & Fine Arts Markets,
Tuesdays 9:30am-2pm
Evening special events and art classes
for children and adults
508-693-1850 www.featherstoneart.org

Featherstone, the island's only year-round non-profit arts center, has gallery shows, workshops, art camps, evenings of music and fundraising events that make it the heart of the Vineyard art scene. Created as the Meetinghouse of Martha's Vineyard in the 80's to encourage community involvement in the arts, the center is located on a six acre parcel with the feel of a working farm, cows and all.. Situated among unspoiled woods and meadows, the center's six buildings house studios, show space and offices. The farmhouse has been converted into a gallery and office space, the main barn, once used as stable for horses, has been transformed into a lofty artist's studio for photography, printmaking and weaving. A tool barn was reinvented as a workshop for woodworking and stained glass. What was once the stable for breed mares and their foals is now the Pottery Studio. On the grounds is an outdoor, wood-fired kiln. The grounds also boast an in ground seven circuit labyrinth and a sculpture garden featuring the works of local Vineyard artists.

Budding artists/artisans/musicians can explore a diversity of crafts through the Center's many workshops led by professionals in a variety of artistic fields. Along with drawing, painting and photography classes, Featherstone's adult offerings are vast, from art to music to writing. Week-long Art camps for kids attract preschoolers to young teens. Special summer events include Musical Mondays. spotlighting local musicians in a bucolic outdoor stage setting, the Featherstone Flea & Fine Arts Market on Tuesdays from late June to early September and a Tuesday Summer Lecture Series. There are also special artist-in-residence classes in beeswax collage and Zen Calligraphy and the ins and outs of arbstract art, a summer poetry series and poetry readings with well-known Vineyard poets.

Turn left out of the driveway onto Barnes, turn left again at the blinking light and head into Edgartown, travelling about 3 miles on Edgartown Vineyard Haven Road. If you're on your bike, the bike trail runs parallel to the street and you'll be travelling about 5 miles total. Continue straight through the stop sign, bearing left to Edgartown Center. You're on Main Street and need to continue going somewhat straight, passing the Whaling Church on the left, until you get to the end of Main. You'll see the Old Sculpin Gallery on the left across from the ferry to Chappaquiddick.

OLD SCULPIN GALLERY - 5
AND STUDIO SCHOOL
MARTHA'S VINEYARD ART ASSOCIATION
Dock Street, Edgartown
Memorial Day weekend-October 15
Mon-Sat 9:30am-9pm, Sun 12pm-8pm
Opening receptions every Sun 6pm-8pm
508-627-4881 • www.oldsculpingallery.org

Established in 1954, the Old Sculpin Gallery and Studio School, is the oldest gallery on the island. Transformed from a sail loft to a whale oil factory to an old grain store to a boat builder's shed, the distinctive building, circa 1881, is itself a work of art. Now run by the Martha's Vineyard Art Association, it serves as the Island's visual arts center. Not only does the gallery represent over 75 years of art made on the Vineyard which is displayed through the summer season, but it also holds studio space for artists in residence and classes for children, teens, and adults. Weekly shows of the 50 members, who must live and work on the Island, run throughout the summer with openings on Sunday evenings.

Leaving the Old Sculpin Gallery, travel up Main Street and make a left onto South Water, then take the first right onto Davis Lane. This dead ends at Pease Point Way. Turn left, then take an immediate right onto Cooks Street, and a left onto West Tisbury Road. You'll be travelling a little under 8 miles to State Road. Turn right following the Vineyard Haven Oak Bluffs signs, traveling about 5 miles. Pass the Ag society on the left and continue following signs to Vineyard Haven. Go through West Tisbury, staying on State Road, toward Vineyard Haven. You'll see the sign on your right to Chilmark Pottery. Following the signs along the dirt road for pottery, the studio/gallery is on your left after the curve.

CHILMARK POTTERY - 6
145 Field View Lane, West Tisbury
Daily March through December, 9:30am-5pm,
Sunday 11:30am-5pm
508-693-6476

A visit to Chilmark Pottery begins on the porch where numerous pieces of pottery of all shapes, sizes and colors are displayed. The selection is impressive, and potter Geoff Borr uses several techniques including raku. Once visitors step inside the barn, more pottery awaits, from plates, bowls and mugs, to vases and vessels of all shapes and sizes. Geoff Borr produces a wide range of styles, both functional and decorative pieces, with some unusual but useful objects: rice bowls, flower cushions, and ramekins to name a few. Geoff can be found arranging the works and answering questions when he is not at the wheel or the kiln.

Turn right out of the driveway, getting back on State Road heading into Vineyard Haven. Travelling a little less than 2 miles, turn left onto Mayflower Lane. Dantzig Glass is the 8th house on the right, with barnboard siding and solar panels on the roof. The studio is attached to the house.

DANTZIG GLASS - 7
135 Mayflower Lane, Vineyard Haven
Year Round
May 1-June 30, Friday-Saturday, 10am-2pm
July 1-August 30, Monday,
Saturday, 10am-2pm (and at Artisans Festival)
September 1-December 24, 10am-2pm;
closed Sundays
January-May, by appointment
508-696-0874 • www.dantzigglass.com

The fused hand-made glass pieces by artist Jeri Dantzig at her home studio in Vineyard Haven are bold and colorful. Large square and circular platters make strong statements with geometric designs and vibrant colors. These are contemporary, even ultra-modern, designs that also possess a certain Island flair. Many designs are repeated on separate pieces, making a collectible set of dinnerware. You will also find a variety of tables-from sofa to coffee—custom mosaic mirrors, Martha's Vineyard window hangings, and sculpture. Jeri also shows her work at Featherstones on Tuesdays.

AG HALL: The Ag Hall is the home of the Martha's Vineyard Agricultural Society. It is a 100-year-old post and beam barn that traveled to the Island piece by piece from New Hampshire; it was put back together by volunteers on a 21-acre site in West Tisbury. The Hall is the location of the Vineyard Artisans Festival on Labor Day and Thanksgiving weekends (the Artisans are also found every Sunday, June through October, and Thursdays July and August at the Grange Hall, also in West Tisbury). The annual Family Planning Art Show is held at the Ag Hall over Memorial Day weekend. The Ag Hall's big event is the annual Martha's Vineyard Agricultural Society Livestock Show and Fair, held in mid-August. The four-day event has been delighting Island visitors for 145 years.

We have placed the Vineyard Artisans Festivals here at the end of the trail, although if you are driving or biking the trail from start to finish, you should visit it as you are in West Tisbury near State Road and West Tisbury Road at the Grange. Just past Allie General Store. The festivals continue over Labor Day weekend at the Agricultural Hall, Columbus Day weekend at the Grange, a big show at the Agricultural Hall over Thanksgiving and a holiday show in December.

VINEYARD ARTISANS FESTIVALS - 8

Summer, Thursday and Sundays - Year Round Sundays until October, special holiday shows 508-693-8989 • www.vineyardartisans.com

The Vineyard Artisans Festivals is a year-round celebration of arts and crafts on Martha's Vineyard that takes place at the historic Grange Hall and the Agricultural Hall in West Tisbury. Started in the 90's by Andrea Rogers as a way to highlight Island artists, 65 of the Vineyard's finest artisans, some of whom are

in this publication, can be found weekly at the Grange, with over 130 artisans at the full weekend Labor Day and Thanksgiving festivals at the Agricultural Hall. A great way to find Island artists who work in home studios, the festivals begin on Memorial Day weekend and take place through the summer on Sundays and Thursdays. Sunday shows continue until October, with additional shows on Labor Day, Columbus Day and Thanksgiving weekend. These juried shows provide an important venue that supports the Island's art community. Exact dates and times are in a catalog available at many galleries or on the festival website.

MARTHA'S VINEYARD FESTIVALS & SPECIAL EVENTS

VINEYARD ARTISANS SPRING FAIR
Memorial Day weekend, Grange Hall,
West Tisbury

FAMILY PLANNING ART SHOW
Memorial Day weekend, Agricultural
Hall, West Tisbury

**TASTE OF THE VINEYARD
GOURMET STROLL**
June Old Whaling Church lawn,
Edgartown

**ANNUAL HARBOR FESTIVAL AND
SUMMER SOLSTICE CELEBRATION**
June Oak Bluffs Harbor

FLEA AND FINE ARTS MARKET
Tuesdays, end of June to first week in
September, Featherstone Center for
the Arts, Oak Bluffs

TISBURY STREET FAIR,
July, Main Street, Vineyard Haven

VINEYARD ARTISANS FAIR
Sundays, June-September; also
Thursdays July and August

GRANGE HALL, WEST TISBURY
All-Island Art Show, August

TABERNACLE, OAK BLUFFS
Vineyard Fine Art Show, August, Grange
Hall, West Tisbury

**ANNUAL MARTHA'S VINEYARD
AGRICULTURAL SOCIETY
LIVESTOCK SHOW AND FAIR,**
August West Tisbury

INTERNATIONAL FILM FESTIVAL,
September

**VINEYARD ARTISANS LABOR DAY
FESTIVAL,**
September, Agricultural Hall,
West Tisbury

TIVOLI DAY,
September, Circuit Avenue, Oak Bluffs

**VINEYARD ARTISANS COLUMBUS
DAY FESTIVAL,**
October, Grange Hall, West Tisbury

**CHOCOLATE FESTIVAL, COLUMBUS
WEEKEND**
Featherstone Center for the Arts,
Oak Bluffs

FOOD AND WINE FESTIVAL,
October

**VINEYARD ARTISANS HOLIDAY
FESTIVAL,**
November (Thanksgiving weekend),
Agricultural Hall, West Tisbury

**VINEYARD CRAFTSMEN ART &
CRAFT SHOW,**
December, MV Regional High School,
Oak Bluffs

CHRISTMAS IN EDGARTOWN,
December, Edgartown

For more information go to
www.mvy./calendar of events.com

GUILDS, FAIRS & HISTORICAL ORGANIZATIONS

Art Guilds & Fairs

Many more artists exhibit in art shows and events sponsored by the numerous guilds and associations in the area. This list is a starting point. Up to date information is printed in our local newspapers, including the Patriot in Barnstable, the Banner in Provincetown, the Enterprise in Falmouth, the Register in Dennis, the Oracle in Chatham, the Cape Codder for the lower Cape. On Martha's Vineyard pick up the Gazette and Martha's Vineyard Times, and on Nantucket the Inquirer and Mirror. In addition, the Cape Cod Times has events listed at www.capecodonline.com. You can also stop in at the local chambers of commerce for each town.

BARNSTABLE

Art in the Village Late June, Barnstable Village, www.capecodartassoc.org

BREWSTER

Brewster Monday Painters, Mondays, June – September, Brewster Council on Aging Building, Rte 6A

Society of Cape Cod Craftsmen, Mid August, 3 days, Drummer Boy Park, Rte 6A

Cape Cod Potters Annual Winter Sale, Week before Thanksgiving, Brewster Ladies Library

CHATHAM

Festival of the Arts, Late August, Chase Park, Chatham, www.capecodcreativearts.org

Guild of Chatham Painters, Thursdays and Fridays, late June to late August Main Street, Chatham

COTUIT

Annual Brush Off, July

DENNIS

Dennis Village Art Walk, Saturdays in June, July, August, Dennis Village along Route 6A

EASTHAM

Eastham Painters' Guild Outdoor Art Shows, Memorial Day weekend, Thursdays and Fridays, late June – Labor Day,

Schoolhouse Museum Weekend Shows, September, and Holiday Indoor Show, Church, Thanksgiving weekend

Hands on the Arts Weekend, June, Windmill Green

HARWICH

Guild of Harwich Artists Art in the Park and art shows, June until Labor Day, Mondays, (rain days, Wednesday), Doane Park

Thursdays and Fridays, Pilgrim Congregational Church, Rte 28

MASHPEE

Mashpee Powwow, First week of July, Mashpee Wampanoag Tribal Grounds, (508) 477-0208

ORLEANS

Nauset Painters, June through Labor Day Tuesdays and Wednesdays, Depot Square Park, Saturdays and Sundays, Sovereign Bank

Artisans' Guild of Cape Cod, July 4th, first week in August, and weekends of Memorial Day, Columbus Day and Thanksgiving, Nauset Middle School,

Artisans Guild of Cape Cod, www.artisansguildcapecod.org

OSTERVILLE

Artisans' Guild of Cape Cod, Last weekend in August, Cape Cod Academy www.artisansguildcapecod.org

Osterville annual Arts in Bloom, Early May, Osterville Village

PROVINCETOWN

Portuguese Festival, June www.ptownchamber.org Provincetown Art Association and Museum, Check their web sites for ongoing special events www.paam.org

YARMOUTH

Yarmouth Art Guild Outdoor Art Show, Sundays July and August Bank of America and Cape Cod Cooperative Bank, Rte 6A, Yarmouth Port

Cultural Center of Cape Cod – Celebration of the Arts, Late June, South Yarmouth

CAPE WIDE

Cape Cod Celtic Festival, Late June, www.capecodcelticfestival.com

Maritime Days, May, events throughout the area www.capecodmaritimedays.com

Annual Fall for the Arts, first weekend in October www.artsfoundation.org

NANTUCKET

Annual Daffodil Festival Weekend, April

The Nantucket Arts Festival, October

Christmas Stroll Weekend, December

Historical Organizations

Below is a partial list of organizations for those interested in exploring local heritage.

BARNSTABLE

Barnstable Historical Society www.barnstablepatriot.com

Cape Cod Maritime Museum Hyannis • 508-775-1723 www.capecodmaritimemuseum.org

Historical Museum Centerville • 508-775-0331 www.centervillehistoricalmuseum.org

Historical Society of Santuit & Cotuit

Cotuit • www.cotuithistoricalsociety.org

JFK Hyannis Museum Hyannis • 508-790-3077 www.jfkhyannismuseum.org

Osterville Historical Society Osterville • www.osterville.org

Tales of Cape Cod www.talesofcapecod.org

BOURNE

Bourne Archives
508-759-6928
www.townofbourne.com

Bourne Historical Society
www.bournehistoricalsoc.org

Bourne Society for
Historical Preservation
Pocasset
www.bournehistoricalsoc.org

BREWSTER

Brewster Historical Society
www.museumsusa.org

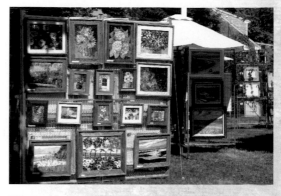

CHATHAM

Chatham Historical Society
www.chathamhistoricalsociety.org

Chatham Marconi Maritime Center
www.chathammarconi.org

DENNIS

Dennis Historical Society
South Dennis • www.dennishistsoc.org

EASTHAM

Eastham Historical Society
North Eastham
www.easthamhistorical.org

FALMOUTH

Falmouth Historical Society
www.falmouthhistoricalsociety.org

Woods Hole Historical Museum
Woods Hole • 508-548-7270
www.woodsholemuseum.org

HARWICH

Cape Cod Genealogical Society
East Harwich
www.capecodgensoc.org
Harwich Historical Society
www.harwichhistoricalsociety.org

MARTHA'S VINEYARD

Martha's Vineyard
Historical Society
Edgartown • www.mvmuseum.org

MASHPEE

Mashpee Historical Commission
www.vma.cape.com/~historic

NANTUCKET

Nantucket Historical Association
508-228-1894 • www.nha.org

ORLEANS

French Cable Station Museum
508-255-6616
www.atlantic-cable.com
Orleans Historical Society
www.orleanshistory.org

SANDWICH

Thornton W. Burgess Society
East Sandwich • 508-888-6870
www.thorntonburgess.org

TRURO

Truro Historical Society
www.trurohistorical.org

WELLFLEET

Wellfleet Historical Society
www.wellfleethistoricalsociety.com

YARMOUTH

Cape Cod Maritime Research
Yarmouth Port
www.capecodgensoc.org
Historical Society of
Old Yarmouth
Yarmouth Port • www.hsoy.org
Yarmouth History Commission
South Yarmouth
www.hsoy.org

\mathcal{I}NDEX BY STUDIO (A-Z)

\mathcal{A}RTIST BY CATEGORY

Artist by Medium

Galleries

Listed in this index are galleries where the visitor will find multiple, unrelated artists. These include traditional galleries, artist cooperatives, and artist owned galleries where the owner shows the work of multiple artists.

Centers

with classes, events and many with rotating shows

Museums

\mathcal{H}OW TO ORDER

To order copies of this guide, please contact the

CAPE COD CHAMBER OF COMMERCE

by **phone** at 508-362-3225 or Toll Free 888-33-CAPECOD,

or go **on-line** at www.capeandislandsartsguide.com

Credit and Thanks
from Clare O'Connor, Project Manager

Author
Laura M. Reckford

Design and Publishing
Margo Tabb
Margo Tabb Graphic Design, Inc.

Photography
Thanks to the artists and their families and friends who helped get the images electronically to the designers, as well as to the designer for her added images and to the following photographers:

Jeffrey Allen	Barbara Baker
Bob Barrett	Richard Broderick
Karyn R. Gello	Michael Galvin
Ron Hall	Jon Harris
Michele Joyce	Jonathan Latcham
Diane Marshall	Robert Schellhammer
Tina Trites	Daniel Howell
Felicia Van Bork	Peter Vanderwalker

Christopher Seufert
Historical Society of Old Yarmouth
Nantucket Historical Association

COVER ARTISTS
Painting by
Michael Pearson, Harvest Gallery and Wine Bar
Glass by
Dave McDermott, McDermott Glass
Basket by
Peter Finch, Basketmaker, Nantucket
Bird Bath by
Kevin Nolan, Barnstable Pottery and Art Gallery
Vase (back Cover) by
Ron Dean, Ron Dean Pottery

Very Special Thanks
To the organizations and artists who helped at every step of the way, especially the staffs of the partner organizations. To Bonnie, Anna, and Christina for their enthusiasm and persistence, and Sarah for the original research. To our volunteer readers, trail testers, and drivers. To Wendy Northcross, for the idea, Jeannine Marshall, for getting us the money, and both of them for their solid advice and support. To Handmade staff, for lending expertise and Meri Jenkins for her faith in us. For the Nantucket Island and Martha's Vineyard Chamber staff for their help. To the designer and writer who worked tirelessly to get us to the publication date, and to John Rice, who lived through all the editing, deadlines and trips to studios on weekends and holidays.

THE PASSPORT TO THE ARTS OFFERS discounted admission to 45 arts and culture attractions on Cape Cod. Art lovers can use the Passport to explore Cape Cod's world-class cultural community through our museums, theaters, music, and heritage.

PASSPORTS are available for just $20 from the Arts Foundation of Cape Cod and select member venues.

SOME BLACKOUTS and restrictions apply, so always contact the venue for details ahead of time. Passports are valid through May 2010 and may only be redeemed once per venue. For more information on the Passport to the Arts, please visit the Arts Foundation of Cape Cod at **www.artsfoundation.org** or call 508-362-0066.

THE ARTS FOUNDATION OF CAPE COD is the designated local arts agency for Barnstable County, a resource for the arts and culture community of Cape Cod since 1988. The Arts Foundation of Cape Cod fulfills its mission by serving as a professional resource for artists and cultural organizations, an informational resource for the public, and as the voice of the Cape Cod arts community through advocacy and support.

Explore the richness of Cape Cod's arts and culture! The Passport to the Arts offers discounted admission at these Cape Cod venues:

Academy of Performing Arts
Bourne Historical Society
Bourne Society for Historic Preservation
Cahoon Museum of American Art
Cape Cod Art Association
Cape Cod Center for the Arts
Cape Cod Chamber Music Festival
Cape Cod Children's Museum
Cape Cod Chorale
Cape Cod Maritime Museum
Cape Cod Museum of Art
Cape Cod Museum of Natural History
Cape Cod Opera
Cape Cod Symphony Orchestra
Cape Cod Theatre Project
Cape Playhouse
Cape Rep Theatre
Chatham Chorale and Chamber Singers

Chatham Drama Guild
Chatham Historical Society
Cotuit Center for the Arts
Cultural Center of Cape Cod
Edward Gorey House
Elements Theatre Company
Eventide Arts
Falmouth Museums on the Green
Four C's Theater
Harwich Junior Theatre
Heritage Museums & Gardens
Highfield Hall
John F. Kennedy Hyannis Museum
Monomoy Theatre
Opera New England of Cape Cod
Osterville Historical Society and Museum
Outer Cape Chorale
Payomet Performing Arts Center in Truro
Pilgrim Monument and Provincetown Museum
Provincetown Art Association and Museum
Provincetown Tennessee Williams Theater Festival
Sandwich Glass Museum
Truro Center for the Arts at Castle Hill
Wellfleet Harbor Actors Theater
WOMR
Woods Hole Theater Company
Zion Union Heritage Museum

ARTS FOUNDATION
O F C A P E C O D

Slip this book under your arm and hit the trails!

This second edition of the Arts and Artisans Trails of Cape Cod, Martha's Vineyard and Nantucket guides you on seven itineraries to visits with over 200 artists and artisans. It's like having your own personal guide along with you. Completely revised with new artists, new images, new articles and improved maps, the routes, photography and side stories invite you to experience this area known for its natural beauty from a different perspective. Choose where to go inspired by the many photographs. Along the way, you'll find some truly remarkable pieces of art-in barns, perched on cranberry boxes, and in studios overlooking vistas that inspire our artists every day.

Look for new 2010 publication, The Sourcebook of Handcrafted Architectural Elements, created to link a wider group of regional artists to builders, architects, and interior designers. It will also be available for purchase by the general public.